# BEAR MEMORIES
## THE CHICAGO-GREEN BAY RIVALRY

# BEAR MEMORIES

## THE CHICAGO-GREEN BAY RIVALRY

*Beth Gorr*

Published by Arcadia Publishing
Charleston SC, Chicago IL, Portsmouth NH, San Francisco CA

Printed in the United States of America

Library of Congress Catalog Card Number: 2005931512

For all general information contact Arcadia Publishing at:
Telephone 843-853-2070
Fax 843-853-0044
E-mail sales@arcadiapublishing.com
For customer service and orders:
Toll-Free 1-888-313-2665

Visit us on the Internet at www.arcadiapublishing.com

*For Chuck Mather, the Coach*

# CONTENTS

# ACKNOWLEDGMENTS

A heartfelt thank you to all of the Bears, past and present, who have so generously shared your time and your memories. You have made the past come alive and have made this experience a memorable one.

For the support of family and friends whose patience and forbearance during the course of countless football stories made this project possible.

For my husband Fred who always sees life in a positive light, and who loves the Bears as much as I do.

For mentors and coworkers. It's been an interesting journey.

For my father, Ed Wheeler, sports reporter and diehard Bears fan; and my mother, Barbara Milnor, who never misses a game.

The following sources have been invaluable during the research phase for this book:

*Mudbaths and Bloodbaths*, by Gary D'Amato and Cliff Christl.
*The Chicago Bears: An Illustrated History*; *What Bears They Were*, and *Sunday's Heroes*, by Dick Whittingham.
*Tales from the Chicago Bears Sidelines*, by John Mullin.
*Papa Bear*, by Jeff Davis.
*Total Football, the Official Encyclopedia of the NFL*, by Bob Carroll, Michael Gershman, David Neft, and John Thorn.
*Chicago Bears History*, by Roy Taylor
*The Chicago Bears Media Guide*, 2004.
*Bear Report*, Jason Klabacha, editor.

# FOREWORD
## BY MIKE PYLE
### 1961–1969

I grew up in the Chicago area and by the time I joined the Bears, I was pretty sure that there wasn't too much about the Bears-Packers rivalry that I didn't already know. I'd followed the Bears for years as a fan. My dad had season tickets and during junior and senior years in high school, and a friend and I used to go to every single game. When I was at Yale, of course, I wasn't able to attend the games in person, but I read everything I could in the local papers.

One of the first things I heard as a rookie was Hugh Gallarneau's old Bears-Packers stories. He used to love to tell the one about his teammate, Lee Artoe. Artoe was one tough son-of-a-gun, and the Packers as a team took a particularly strong disliking to him. The way Hugh related things, at the end of one of the games during the early 1940s, one of the Green Bay guys grabbed Artoe and pinned his arms behind him. Then the other Green Bay player gave Artoe a tremendous haymaker punch that shattered Lee's jaw. This was well before the days of face masks, so Artoe had no way to protect himself. It was a brutal move but, according to Gallarneau, pretty much in keeping with the spirit of those early games. When I heard that tale, my first thought was that perhaps I had underestimated the intensity of the Bears-Green Bay rivalry entirely.

The history of these games is a great one, full of violent competition and outstanding play. Although the balance between the two teams has not always been equal, Bear-Packers meetings tended to be the types of occasions where one group or another would rise up and play far beyond their normal skill level. You never knew for sure going in who would come out on top when the fourth quarter had ended.

Many of those who were with the Bears during the 1960s, when I played, will tell you that their most memorable Bears-Packers game was the last meeting of the 1963 season, and—for the most part—I would agree. 1963 of course was the year that the Bears won the championship. We knew at the start of the season that the only way we'd have even a chance at post-season play was to knock Green Bay out both times we met them. Coach George S. Halas had special game plans devised just for that circumstance; in fact, we extended training camp a week, traveling up to DeKalb, Illinois, to work on those plans exclusively.

We beat Green Bay in the first week of the season 10-3, which set us on the right track. That first meeting gave us the positive momentum that carried us right through week 14. It wasn't that we thought early in September we'd win it all; it's just that we began to see a championship as a realistic possibility. Everything built form that point on.

The second meeting between the two teams that year was at home, on November 17. That week in Chicago was incredible. It was as if the entire city united in this one effort. The media, the team, the fans—we were all in this together. This was something very different from the usual buildup that starts the day of a game. It was more of a crescendo, a feeling that grew exponentially throughout the entire week leading up to the Sunday afternoon kickoff. Everywhere we went—everything we did—the excitement was palpable.

By Sunday morning when we arrived at Wrigley Field, we could hardly contain ourselves. The air was that electric. J. C. Caroline set the tone for the afternoon with a jarring hit on the very

first play. I'd never seen anything like it. That's when we took over the game completely and went on to a 26-7 pounding of a team that going into the season had been favored to win it all. It was exciting and exhilarating, an experience like none other. And after the game—complete jubilation. It's funny, because looking back I remember every detail of the days before the game, but almost nothing of the hours afterwards. That tells you just how hard we were celebrating.

There were some good years against the Packers when I played, and some not so good years. The worst was during 1964, when we lost Bo Farrington and Willie Galimore. Their deaths broke our spirits that season and we just couldn't focus enough on the job at hand.

The most intense game I ever played in was in 1968, which was a loss at home against the Packers. If we'd have won we'd have been headed to the playoffs. (Instead the Vikings got the chance to advance.) I was underweight that year, coming into the season with a low grade infection I'd picked up while traveling overseas on my honeymoon just before training camp. There were other physical problems among members of the team, enough to keep us from dominating the way we felt we could have.

The Packers were killing us in the first half, leading by a score of 21-0. Near the end of the second quarter, George Seals, who was a heck of a player but who was hated by Green Bay, went down hard, completely tearing his knee. The next thing we knew, linebacker Ray Nitschke was standing over him—laughing. The Bears players looked at each other, incredulous at what we'd just witnessed, and when we went to the huddle the first thing anybody said is "Let's do this thing for George." It was no holds barred from that point on.

The first half came to an end, and we headed to the locker room where we devised a second-half game plan. As we came out after halftime, we looked possessed. Seeing the films later, all I noticed from the Bears was anger. Everybody was just killing themselves out there on the field. Gale Sayers was hurt and Brian Picollo had gone in. Pic was working like a maniac, just churning away. I think he had his best game ever that day. Everybody seemed to pick things up a notch. We scored once, twice, three times—all on running plays. We had players going down right and left with all sorts of injuries. It got so bad that our guys were substituting out of their usual positions just to fill the holes. We were playing that hard.

We came back and were close to winning the game, but then, as the seconds ticked down, Concannon threw a bullet right down the middle into the waiting arms of Ray Nitschke. That broke us right then and there. The Packers won 28-27. There's not much to say after a day like that.

We should have learned a lesson from 1962, another year when the Bears vowed to win a game for one of their own. This time it was famed veteran Bill George, who was in the hospital just before a Packer game. A bunch of his friends, all veteran players, went over to see Bill and said, "Don't worry, we'll beat Green Bay for you." That was the game we ended up losing by a humiliating score of 49-0. I can't even imagine what Bill said to his pals when they went back to see him later that day.

Things like that tend to happen when Chicago and Green Bay go face to face. That's why it's hard to put these games into a tidy package. To me, this oldest rivalry in football parallels the growth of the league from hardscrabble guys trying to make a living on dirt fields to high salaried players in state-of-the-art stadiums with a nationwide television audience. It's grown and it's changed, but the basics remain the same.

I thought I knew what it was all about before I joined the Bears, but I was wrong. These contests are so much more than just another Sunday. It's blood and sweat and desire and intensity. And looking back, I always felt that my career would have lasted much longer had I not faced Nitschke and the Green Bay Packers.

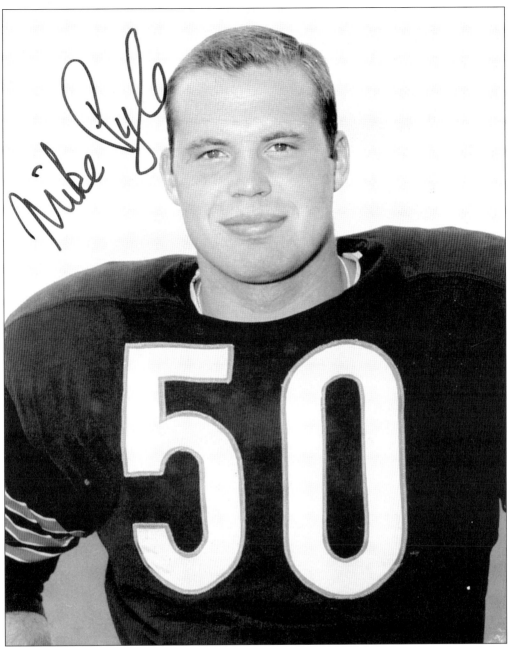

Mike Pyle, former Bear all-pro center, was a longtime Bear fan since childhood who brought his passion for Chicago football into his post-playing days as a radio sports analyst.

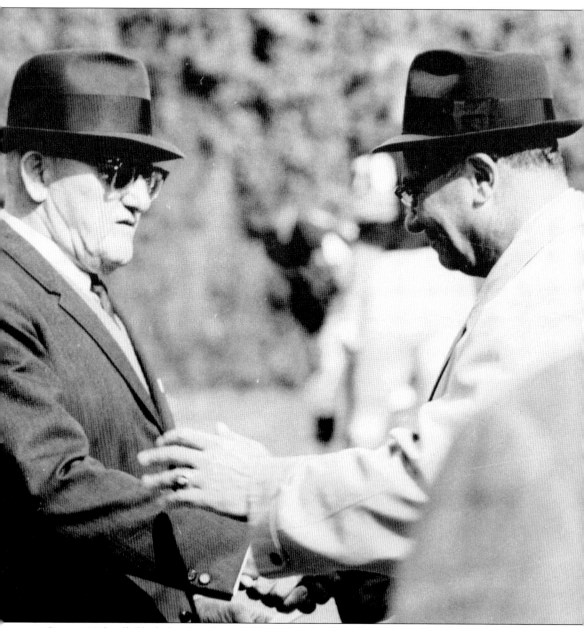

George Halas (left) shakes hands with Vince Lombardi before the coaches send their football squads out to resume the NFL's greatest rivalry on an otherwise ordinary Sunday afternoon. (Courtesy of Ron Nelson at Prairie Street Art.)

# INTRODUCTION
## BY ROY TAYLOR

It is Chicago, the fall of 2001, and for the first time in nearly a decade the city's fans are pulling out of their football doldrums. Chicago Bear football fans are the greatest that exist, in my opinion, but at the time five straight losing seasons had taken their toll.

During that one magical fall, however, the Bears stunned their fans and the NFL by jumping out to a 9-2 record and control of the NFC Central division as of December 2nd. Chicago's two losses that year came at the hands of the World Champion Baltimore Ravens, and their arch rivals, the Green Bay Packers. Suddenly, Bear fans as well as curious onlookers clamored to attend Bear games.

On the following Sunday stood a monumental contest, a battle between the two oldest rivals in the National Football League—the Bears and Packers—for control of the division. Remarkably, although the two teams had met twice per year, Chicago and Green Bay had not battled for first place this late in the season since 1963.

I have been a Chicago Bears fan since 1979, when as an eight-year-old boy I attended my first game at the then-crumbling Soldier Field. Although I'd been on many Bears road trips, I'd never been to Green Bay for a game. I'd been to Detroit, Minnesota, Cincinnati, and New Orleans—all larger cities fraught with more danger than little Green Bay—but frankly I was a little nervous about our neighbors up north. Strolling the Lambeau Field parking lot in my Dick Butkus jersey, I pictured myself as pure anathema to Packer fans.

Regardless, I sought tickets but could not find any. The following Saturday night, I received a call from Don "Bearman" Wachter, who is known for prowling the Soldier Field sidelines in his stuffed Bear head. Could I join him at Sunday's game at Lambeau and use his spare ticket? Before he could finish his sentence I had explained to my wife that I would need to be on the road by 4:00 a.m, headed north.

Green Bay, Wisconsin, is 210 miles due north of downtown Chicago. Close enough to be in the same geographic area, but as Chicagoans and Wisconsinites will agree, worlds apart. Illinois residents may lightly kid their neighbors for being back-woods "cheeseheads," while residents of Wisconsin more often disdainfully refer to their southern rivals as "flatlanders," or use one of several acronyms not suitable for print. Driving time is roughly 3.5 hours, but on this day I will leave before dawn; that will give me enough time to tailgate with friends and enemies alike for four hours prior to the game. The long drive provides ample time to reflect on this great rivalry.

The Bears and Packers have been meeting each other yearly since 1921, the last year the Bears were known by their ancestral name, the Staleys. On this day I will be making a pilgrimage that has traveled both North and South for decades. In the early years, both teams organized raucous train trips for these rivalry games, featuring passenger cars packed with eager and often intoxicated fans.

The years 1921 through 1946 must have been a glorious era for the combined fan base of these two teams. Over those 36 seasons, the Bears and Packers combined to win 13 NFL Championships. The Bears lead the NFL with 26 primary members of the Pro Football Hall of Fame; the Packers are second with 20. Of these 46 players, 23 of them played for the teams during this era.

As I reach the Illinois-Wisconsin border, or what may be regarded by many as the DMZ of the two states, I see the wood-carved State of Wisconsin sign and the Mars Cheese Castle, which is surely disdained by local residents.

At this point, I begin to think of the many famous, and infamous, moments that have marked the Bears-Packers rivalry. Throughout the 1950s, as the Bears were solidifying their no-nonsense, "Monsters of the Midway" image, and opposing players often put bounties on each others' heads. And many times their teammates made good on these offers. The Bears were kept awake at all hours in Green Bay's Northland Hotel by obnoxious locals, marching bands, and fire drills, and players were told to wear full equipment in public to protect themselves from flying objects. Bear great Ed Sprinkle, one of the most feared defenders of his time, even recalled answering founder and coach George Halas's request to deliver a few hairs from the moustache of a Packer player. Yes, football is a contact sport, as Sprinkle explained.

At the onset of the fabled 1963 Bears championship season, Halas warned his players that the only way to win the title that year was to beat the two-time defending champion Packers. Halas' words were prophetic—Chicago defeated Green Bay twice and took the title.

In 1968, Chicago needed a victory in the final week of the season to make the playoffs, and trailed the Packers 28-10 in the fourth quarter. Despite a frenzied comeback, the Bears lost 28-27, which dashed their postseason hopes.

The 1970s featured equally poor Bear and Packer teams for the most part, but were punctuated by the antics of comical Bear coach Abe Gibron. Saving his best material for Green Bay, Gibron would unleash a running back to hunt down longtime Packer kicker Chester Marcol, whom he dubbed the "Polish Prince." When threatened with league action, Gibron suggested the rules-makers ought to turn the game into two-hand touch.

During a crazy 1980 for the two clubs, the initial game was decided on a Marcol touchdown after a blocked field goal. The ball bounced directly back into the arms of the kicker, who scampered left into the end zone for the unforgettable game winner. Chicago won that season's rematch by the incredible score of 61-7.

Even considering the preceding events, no era of Bear-Packer football was filled with more drama than what can simply be called "The Ditka Years." Chicago's hiring of legendary Bear Mike Ditka roughly coincided with Green Bay's employment of Packer legend Forrest Gregg. The two cataclysmic coaches, who never cared much for each other as players, collided with fury from 1984 to 1987.

The Bears, clearly on top of the NFL during this time, defeated Gregg in seven of the eight contests in which they played. Whether Gregg had anything to do with it or not, his players resorted to a multitude of cheap shots during the era, culminating with a dirty late-hit by Packer defender Charles Martin on Bear quarterback Jim McMahon in 1986. The act ended McMahon's season and very likely may have cost Chicago their chance at a second Super Bowl victory.

Following Ditka's firing in 1992, Green Bay embarked on a dominating decade against the Bears, winning eleven straight games against Chicago. This hex was finally broken in 1999, when an emotional Bears team captured a stunning victory in Green Bay six days after the death of Walter Payton.

That December morning in 2001, I arrived in Green Bay for my customary tailgating, and found that Green Bay isn't as scary for a Bear fan as I feared. After a few hours of sharing my motto with Packer fans—we should talk about how much we hate each other's teams, and then be friends—I watched the Bears lose to the Packers 17-7 and drop to second place in the division.

On the way out of the stadium I was subjected to an endless loop of the Green Bay city anthem, "The Bears Still Suck," blasting from what seemed like hundreds of synchronous speakers. Transfixed by the music (as they call it up there) I wondered if I was in the grips of temporary insanity or if this was the beginning of yet another chapter of Bear-Packer history to be recounted by later generations of Chicago football fans.

Bear Historian Roy Taylor (left) gets ready for the Bears-Packers game with Superfan Don Wachter at Lambeau Field, 2004. (Courtesy of Roy Taylor.)

Coach Halas looks on in his trademark dark suit and shades as his Bears square off against archrival Green Bay. (Courtesy of Ron Nelson at Prairie Street Art.)

# One

# BEAR MEMORIES

As a close friend of the coach's son, "Mugs" Halas, Frank Kasper was witness to the Bears from the inside out. Kasper lived every diehard fan's dream, having countless opportunities to meet team members and coaches and travel with members of the organization as they ventured up to Green Bay for Bears-Packers games.

Kasper relates some of what he saw:

> My family was always pretty close to the Halas family. We were in the same parish and Mugs and I attended the same schools. I was in his wedding party and also served as a pallbearer at his funeral. Mugs was godfather to my first born child. That says a lot about how close we were.
>
> To me, George Halas was always my best friend's father. At the time, I'd never think of calling him "coach" and definitely not "George." He was Mr. Halas to me the first time we met and so he always remained.
>
> Mr. Halas' tightfistedness with a dollar was as much fact as fiction. I know first hand from an experience a friend and I had at training camp in Rensser, Indiana. I called Mr. Halas a few days before camp began, telling him that I had a customer with a twelve year old son who was crazy about football. Was it OK if we stopped by to see an afternoon practice? This was quite a favor as camp was completely closed to outsiders.
>
> Mr. Halas said, "Yes, but I suppose you'll want lunch." "No sir," I said "Practice doesn't begin until three and we'll be there shortly before then." "That's even worse," Mr. Halas replied. "I guess I'll have to give you dinner." And so he did.
>
> That afternoon at practice was memorable to say the least. Once we arrived, all we could see on the field was a series of poles staked into the ground with some sort of cheesecloth stretched between them, blocking our view of the players. Evidently, this was one of Mr. Halas' methods for making sure no NFL spies were stealing his game plans.
>
> As we stood there, the most amazing string of expletives emerged from behind that curtain. I'd never in my life heard such language. I turned to my customer and said, looking at his son "If he didn't know those words already, he certainly knows them now."
>
> My customer said "Either he doesn't know them, or he's really good at playing dumb." Needless to say, it was quite an afternoon.
>
> One of the most exciting things that I ever had the opportunity to do with the team was to travel on the train when the Bears went to Green Bay. I remember how it stopped at Central Street in Evanston where we'd all get on.
>
> The team had 2 or 3 cars all to themselves. As a "hanger on," I was fortunate enough to have a space in that section. These were the traditional smoking cars, although few if any of the personnel on those trips had that habit. It was wild, an amazing experience. There would be fans and players all over the place, everybody really excited about what was about to take place. If they won, the trip home would be bedlam. If they lost, then things would be considerably more subdued.

I was never much of a hero worshiper growing up. I had quite a bit of contact through the Halas family with members of the Bears, so this wasn't an out of the ordinary experience for me. But I have to admit that traveling with these players, Casares, Stan Jones, Abe Gibron and the like was impressive to say the least. Most of them were younger than I was at the time, but I still looked up to them. These men were incredibly impressive. They were athletes through and through.

Rudy Custer, who was Halas' right hand man, was a wealth of inside information on just about anything related to the team or to the Coach himself. You could ask him just any question and he'd know the answer. Oh, the stories he could tell. I learned so much about football and about life on these trips up north.

One day Rudy called me a few days before a Bears-Packers game. He said "Frank I've got two good tickets. Why don't you and your wife come up with us to Wisconsin? You'll have great seats. It'll be a lot of fun."

Now that was too good of an offer to consider refusing, so of course I said yes. We got on the train and went up to Green Bay. On game day, we went into the stadium and were guided to our seats. Somehow they weren't exactly what Rudy had described. Instead of having a 'perfect view of the field' we couldn't see much of anything because we were directly behind the Packers bench.

Not only that, but our seats were considerably below ground level, hard against the stadium's walls. The crown of the field was right above our line of sight. If we struggled, we might see a player's feet, but that was about it. Actually, our best view was of their rear ends. Not the most appealing view, to be sure.

We laughed afterwards that it was one of the longest afternoons that we'd ever spent at a professional football game. When I think now of games in Green Bay, I remember that particular day and our view of the backsides and cleats of every single Packer player.

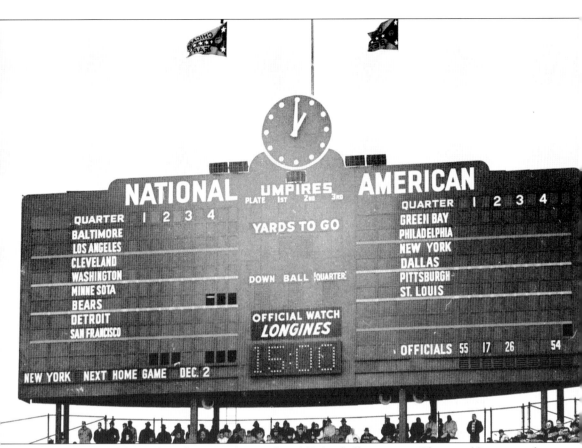

The Wrigley field scoreboard is seen during the 1962 football season in Chicago. (Courtesy of Ron Nelson at Prairie Street Art.)

# Ed Sprinkle
1944–1955

During his playing days, Ed Sprinkle, or "The Claw" as he was popularly known, was characterized as one of the meanest players in professional football. To have earned that moniker meant quite a bit in those days when rough and tumble play was the rule, not the exception. Even legendary Bears coach George Halas often spoke of Sprinkle as being one of the toughest players he'd ever coached.

Although Sprinkle was well cast in his ultimate role as a quintessential Monster of the Midway, his early career path seemed to be headed in a very different direction. As a plain spoken and down to earth student at Hardin-Simmons College where he starred as a starting guard, Sprinkle had few aspirations to play professional football. Sprinkle instead saw his future in the field of math and engineering, his college major. All that changed when Sprinkle's abilities were brought to Halas's attention by fellow Hardin-Simmons alum and Bears great, Clyde "Bulldog" Turner.

Due to the impact of World War II during the early 1940s, every team in the National Football League was hard pressed to find players with the size and skill required to fill their rosters. The Bears were struggling to find a viable solution, and had almost run out of options. Things had become so desperate for Chicago that Halas brought in older retired players such as Sid Luckman's backup, Gene Ronzani.

Halas usually didn't like to sign players he hadn't seen himself, but in this case, he took Turner's advice. It was a gamble that eventually paid off handsomely for the Bears. Halas issued an invitation to Sprinkle to come to Chicago and join the team on a probationary basis. Sprinkle tells the rest of the story:

> It never dawned on me that I had to actually try out for the team. I was so young and inexperienced I thought that once they gave you the uniform, you were part of things for good. Unfortunately, that wasn't the case. I gave it my best shot but it was clear to me that Halas wasn't pleased with what he was seeing. Things got so bad that one day I heard him talking to his assistant coaches about whether or not to keep me on the roster.
>
> Luckily, Turner also heard what was going on and put in a few good words for me. Eventually, Halas, Luke Johnsos and Hunk Anderson relented and gave me another chance. I was incredibly grateful to Turner. Without his intervention, I probably wouldn't have made it.
>
> Life in the NFL was somewhat of a shock to me. There was little money because at that time there weren't that many fans going to the games. It wasn't anything like today with the huge crowds and the enormous salaries.
>
> I soon learned that the only way I could get by financially was if I could get a good job during the off season. That's where my engineering background came in handy. I wound up working part time at Inland Steel when we weren't playing. I even got an unexpected bonus during my time there. That's where I first met my wife, who was one of the company's secretaries.
>
> Back when I started playing, a typical salary ranged from $100 to $200 per game. Can you imagine owners getting away with that now? And the fact that the league's season was only ten games long made things difficult financially. Luckily, my wife kept her job so we always had that steady income to see us through.
>
> I settled in with the Bears pretty quickly once Halas finally decided that he wanted to keep me. At the time, I weighed 205 pounds. My height was 6' so I was about average. What distinguished my style was my aggressiveness. I didn't mind hitting anybody and loved to use a clothesline play. It was my trademark move. Although it's is prohibited now, then it was quite acceptable. That's how I got my nickname "The Claw."
>
> Back when I first started with Chicago, the Bears and the Packers were the leading teams in the league. After all, both had been there from the beginning and had earned

the right to a certain respect. Other teams and coaches would watch the way we played and try to copy what we did. We were the prototype of how the game should be played.

When Chicago and Green Bay met, things could get pretty rough. In those days, professional football wasn't that far removed from professional wrestling. Players on both sides tended to come from tough backgrounds. We weren't afraid to get in there and hit hard.

Traveling to Green Bay was always quite an experience. We stayed at the old Northland Hotel, which became a legend in its time. Of course all of the Packers fans knew that we were there so they'd stand outside in the streets all night banging on pans and shouting at us. We tried to ignore them and get some sleep, but we weren't always successful in doing that.

The early games were played in a local high school's stadium. We'd get dressed at the hotel and then they'd bus us over to the stadium. We'd got a lot of grief from Packers fans during this short ride. The crowds were large and quite close to the field. Sometimes there would be as many as 25,000 to 28,000 people in attendance.

You never knew what was going to happen either on or off the field. Although we did have policemen standing close by, it wasn't much of a deterrent. I kept my helmet on throughout the game, whether or not I was about to go in. You didn't want some crazy fan hitting you on the head with a beer bottle that had been thrown from the stands.

Players went in on both sides of the ball, offense and defense. We had to be pretty versatile. I always enjoyed it when the Packers tried to run their plays away from what I was situated. I was pretty fast, so once the ball was snapped, I'd sneak up behind the line and get the other guy before he realized I was there. They said afterwards that I was a dirty player, but that was the way things went in those days. And if they'd had men on their team with the same ability, they would have done exactly the same thing to our players.

At half time, we'd go to the high school and sit on the floor. It was pretty plain as far as facilities were concerned. We never really had much of a chance to get cleaned up or rested before going back out for the second half. Then after the game, we'd head by bus back to the train that would return us to Chicago.

Fans were on the train as well of course. It was quite an event for them, going up with the team to see a game against the Packers. The team had two or three cars and also the use of a dining car. It was great to see the food as we were usually pretty hungry once the game was over. Coach Halas would allow us to have two beers but only if we'd won. If we lost, then there was no beer at all. Some of the players would sneak back to the cars where the fans were sitting in hopes of getting something to drink from them. It usually worked pretty well.

We always enjoyed playing at Wrigley Field. Having our fans so close by was a distinct advantage for out team. The abuse we'd endured in Green Bay was turned right around onto the Packer whenever they visited Chicago.

The pre game routine was quite different from what it is now. Most of us lived on the north side of Chicago. We didn't stay as a team in a hotel the night before a game, although when I was single I lived in a hotel near the field. Game day was very casual. We'd get in our cars and drive to the stadium. Then after the game, we'd get in our cars and go back home.

When I look back at our games with Green Bay what I remember most was the overall respect the teams had for each other. Yes, there was a lot of emotion involved. There was nothing we'd rather have happen than to beat those guys from Wisconsin. But these two teams were the foundation of the league. We were all aware of that fact and of the tradition involved. At the end of the day, there was grudging admiration. It always made facing the Packers something special.

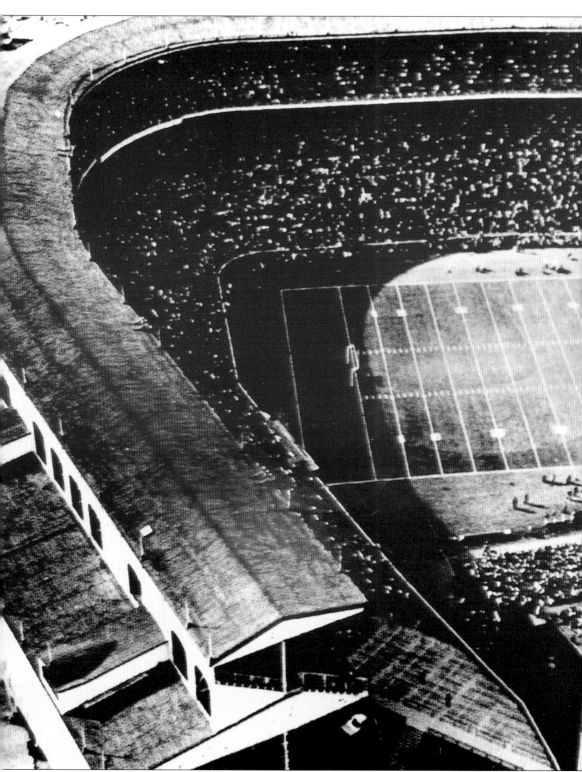

An aerial view of Wrigley Field shows game-day crowds in the mid-1950s.

# Ken Kavanaugh
1940–1941, 1945–1950

Wide Receiver Ken Kavanaugh was as tough as they came, even by the no-holds-barred standards of the game as it was played during the early 1940s. A native of Little Rock, Arkansas, Kavanaugh and his family struggled through the Great Depression before Ken went on to earn All-American football honors at Louisiana State University.

Kavanaugh joined the Bears in 1940 and played for the team until the Japanese attack on Pearl Harbor in December of 1941. Kavanaugh entered the military shortly thereafter, signing up to become a pilot in the Air Force. He was assigned to anti-submarine duty in the Caribbean before shipping overseas to pilot B-24 and B-17 bombers from a base in England for the remainder of the war. He totaled an impressive 30 missions against Germany before returning to the United States as the conflict came to a close in 1945.

Kavanaugh returned to the Bears in 1945 after receiving the Distinguished Flying Cross for "Extraordinary achievement while serving as a commander on heavy bombardment missions against the enemy." Not surprisingly, Kavanaugh also earned All-Pro honors shortly after rejoining the team. He retired from the Bears at the conclusion of the 1950 season. His career totals while with Chicago were an impressive 162 receptions for 3,626 yards. His receiving average of 22.4 yards per carry still tops the Bears all-time record book and he also holds the record for the most touchdowns per catch.

Kavanaugh is listed as one of the NFL's 300 All-Time Greatest Players and was on the NFL Hall of Fame team for the 1940s. He is a member of the Bears All-Time Team. Kavanaugh's achievements on the field in college earned him election to the National Collegiate Hall of Fame, the LSU Hall of Fame, the Louisiana Football Hall of Fame, and the Arkansas Hall of Fame.

Ken and Ann, his wife of 62 years, are currently enjoying retirement in Florida where they are active in charity and fund-raising events. But even after the passage of so many years, the contests between the Bears and Packers remain quite vivid in this Bears legend's memory.

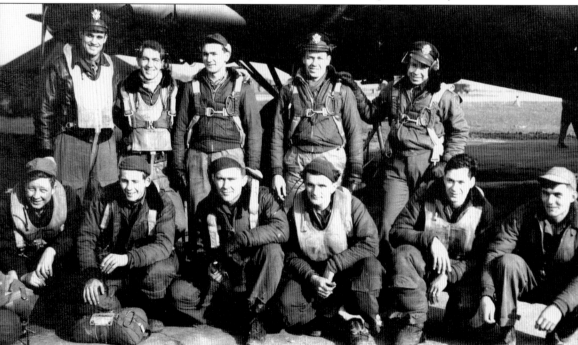

Ken Kavanaugh (top left) poses with his World War II B-17 bombing crew. (Courtesy of Ken Kavanaugh Jr.)

Coach Halas was always all business, especially when we were going against Green Bay. It was the long standing feud he'd had with Curly Lambeau that started everything. They just couldn't stand each other on or off the field.

Halas always implemented strict rules for his players, but when we traveled up north, things became much tighter. There was always a monetary fine system in place. The penalties for talking to anybody when we were on the road for those Green Bay games were severe. I guess that Halas didn't want to take the chance we'd be giving away any game related secrets. We couldn't even have a conversation with the Chicago reporters. Everybody was completely off limits.

He'd charge us around $50 for any infraction. That was as much as many of the players were making for each game. So essentially, if Halas caught you breaking the rules, you'd be playing for free that day.

We'd stay at the Northland Hotel which no longer exists. I personally didn't have any run-ins with Green Bay fans while we were there because I was being so careful not to break any of the team rules. I needed all of the money that I could get at that time.

I did have one near dust up with the coach when we were traveling home from a Green Bay game. We were all in the designated team car on the train back to Chicago. It had been a really long day and I'd snuck some of my favorite drink, which was a bourbon and Coke, on to the train with me.

Halas used to patrol the aisles, walking back and forth seeing if he could catch us doing anything wrong. Every time I saw him coming, I'd stick my bottle in that crevice between the seats. It worked well until one time he snuck up on me. He bellowed "Kavanaugh, what's that you're holding in your hand?" "A Coke, coach" is all I could think of in way of a reply. "All right then, if that's just a Coke then I'm going to taste it," so he grabbed the bottle right out of my hand and proceeded to take a swig.

Luckily for me, Halas had been drinking quite a bit himself that day. He tasted the drink and gave the bottle back to me. "Kavanaugh, you're right. That was Coke." Then he went on his way.

Bottles were a hazard in their own right whenever we played the Packers. I always felt the situation was much worse in Green Bay because the targets there were always members of our team. Early in the contests, you'd get maybe one of two thrown in the general direction of our bench. By half-time, you'd be up to five, six or more. By the end of the game, you had to duck because they seemed to be flying at us from everywhere.

There was one year we were up there and a Packer fan drowned in a little creek that wasn't too far from the stadium. It was only about a hundred yards wide and not too deep but this fellow was impaired at the time.

My wife heard him saying before the game began that if the Packers couldn't beat the Bears, he'd walk right into the water. Unfortunately, he got pretty drunk as the game progressed and by the time we won, he was nowhere to be found. Then somebody saw him floating in the water. I guess he'd walked in there and couldn't get out. That was the strangest ending to a Bears-Packers game that I can recall.

One time I remember that one of the Packer receivers dropped a pass right in front of our bench. He said something not too complimentary about our team and we remembered his sentiments to the exact word. As few plays later I was in and I saw a pass coming to me. I turned around and grabbed it, then headed right into the end zone. We won by that touchdown. My guess is that the player in question never again said anything to his opponents while they were sitting on the bench.

One final story that comes to mind is something that happened at Wrigley Field. I'm not sure of the exact year as this took place quite a few years ago, but I do remember that it involved a popcorn vendor.

Green Bay had a lot of dirty players back then in the '40s. They'd just as soon hit you as look at you. One of them came after my roommate and friend, Lee Artoe

and hit him square in the jaw with his elbow. This was well before face masks were required so you knew that the damage would be severe.

Lee had his jaw broken and a bunch of his teeth knocked out. They took him right into the locker room to be looked after. We sat there waiting for him to return to the game, but he'd been so badly injured that he just couldn't make it.

After the game, the Bears players had to climb up a narrow flight of steps that led from the dugout up to the locker room area. This vendor and his cart were in a little alcove right along our path. As we went by he said "Artoe got what he deserved."

I was having none of that so I whirled around and grabbed him by the neck. I'm a pretty big guy anyway and of course I still had my pads on so it wasn't an even match. I took him and thrust him into a small telephone booth that was situated right beside the dugout stairs.

Then I lifted him to the top of the booth and started punching him. Luckily for him, one of my teammates happened by while all this was happening and said, "Ken, you're in uniform. You can't do that," so I finally let the vendor go. He'd lost his hat and his little popcorn bags were scatted all over the place. It wasn't a pretty sight. But I guess that gives you a pretty good idea of just how intense those Green Bay-Chicago games really were.

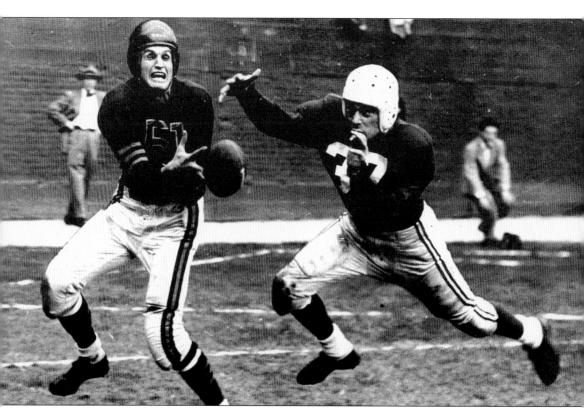

Kavanaugh grabs a pass against the Chicago Cardinals (that other rivalry) in 1940. (Courtesy of Ken Kavanaugh Jr.)

24

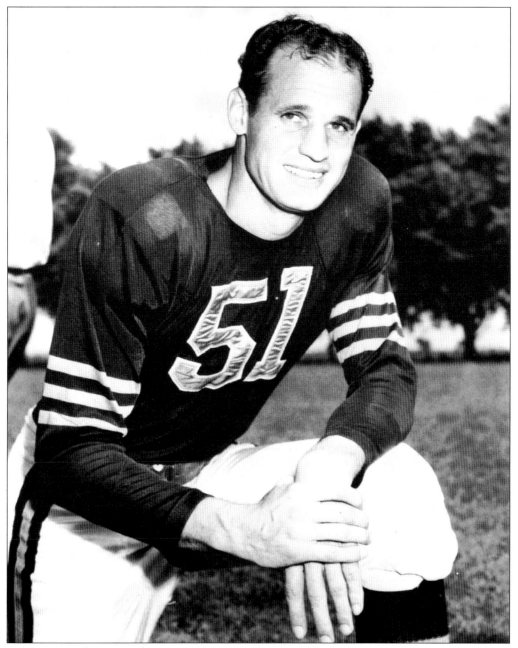

Ken Kavanaugh poses in his Bears uniform in the 1940s. (Courtesy of Ken Kavanaugh Jr.)

# Harlon Hill
1954–1961

As a student at Alabama's Florence State Teachers College, young Harlon Hill's dream was to become a high school principal. Although he did enjoy playing football, it seemed more of way to pass the time than the fast track to a star studded career. That all changed when Bears coach Clark Shaughnessy happened to see Hill and his teammates going against Jackson State.

"How many players ever make it to the pros from a college the size of Florence State? I'd never even considered that path," Hill recently said, "Shaughnessy and Halas were in the area for a Blue Gray game. It was complete luck for me that Clark came by Florence State first. Later that weekend, Clark told the Coach that 'the best receiver in the country is not in the Blue Gray game,' which at that time was open only to players coming from much larger programs."

With Halas's approval, Shaughnessy asked Hill's college coach to send some film back to Chicago. While not overwhelmed by Hill's skill, the Bears staff was sufficiently impressed to draft him as the 15th pick in 1954.

> I was overwhelmed. I had such limited experience at that time. The city of Chicago itself was dazzling to me. Just think of the impression a place like that would have made from a boy raised in a small town in Alabama. And to play on an NFL team? That was completely unbelievable.

Hill quickly adjusted, however, and became one of the most impressive players in the history of the franchise. Even today, his statistics remain near the top of the Bears All-Time list. Many of his records still stand, a feat made even more remarkable considering that Hill endured a completely torn ACL during the last three years of his career. As a receiver, he holds the Bear single games records for touchdowns (4) and yards (214) to this day. His career totals include nineteen 100-yard games (first all-time in Bears annals), 4,616 yards (second), and 40 touchdowns (second).

A strong willed and individualistic man, Hill felt right at home with the cast of characters found on the Bears' roster during those days. Stan Jones, Doug Atkins, and a young Mike Ditka became fast friends. However one opposing player, the Cardinal's Pat Summerall, had another opinion.

The facts of the story according to Hill are that George Blanda threw a deep interception against the Cardinals. The enraged quarterback then charged across the field after the Cardinal player eventually catching him then throwing him to the turf. Not content to have made the stop, Blanda then began to kick and punch the downed Cardinal. Pat Summerall, who was standing nearby, went after Blanda. Hill then confronted Summerall.

Things soon deteriorated into an all out bench clearing brawl. Unfortunately for Hill, a national photographer on the sidelines captured the image of Hill and Summerall slugging it out.

> The next day, it was on the front page of every sports section. I got a bad rap for that one. Everybody said that I was a rough player. All I was doing was protecting my quarterback. "It was one of those things that happen in football" Hill said later. I never took it personally but evidently Pat did.

After an amazingly productive career, Hill eventually retired as the 1961 season drew to a close. He returned to Florence State where he earned his degree in school administration. Hill then became a high school principal and prep football coach. "See, dreams do come true," he said recently. Hill looks back on his memories of Green Bay:

> There was one Packer by the name of, Bobby Dillon, who was around when I was. Bobby was a great player but I'd found out that he was blind in one eye. I had a good idea which eye bothered him and made a point of always heading to that side

when I was about to make a big play. It seemed to work pretty well and I was feeling very smart for having figured out how to work him.

Then one day after we both were retired I ran into Bobby. I was laughing and telling him that I'd known all along about his infirmity and that I'd been able to get around him pretty well because of it. That's when he told me "Harlon, Didn't you know that I was blind in the other eye? Anything you got on me was all dumb luck." That took the wind right out of my sails.

I can't stress enough the intensity of contests against Green Bay. That was a real all or nothing situation. Coach Halas left as little to chance as possible. He'd even check the weather, practically on an hourly basis. I'm pretty sure he employed a weatherman full time just for that.

The funny thing was that this fellow was only right about half of the time. He'd say it would be freezing and it would be warm, or he'd predict heavy rains and we'd have a dry spell. That made the Coach furious, needless to say.

The Green Bay games were always grudge matches. They were the only game you would do anything not to lose. Spirits always ran high which is why you'd see such hard hits and quite a few injuries.

The early years that I played with the Bears, Green Bay wasn't that great overall. Their record was mediocre. But I noticed a tremendous change when Lombardi took over. He was a tough knowledgeable coach who always got the best from his players. Just like Halas, Lombardi would do just about anything to win.

We worked hard before all of our games, but the intensity before a game against Green Bay was unbelievable. We'd adjust and readjust, building up into a frenzy. It was a matter of attitude and mood. We always fought hard but against the Packers, things were at an entirely different level. The highs and lows lasted long after the game was over. If you won, you'd feel great for weeks. If you lost, it would be difficult to forget.

They say that Chicago is the Windy City. Not to me. For most of the Bears players, that place was Green Bay. And the snow. Mounds of it everywhere. What a shock for a young man from Alabama. It was so cold and the wind would get so fierce you hardly knew how you would get through to the end of the game. It often got down to a matter of sheer survival. We played on pure instinct, almost like animals.

The train trips, everybody knows about those. They were events in themselves, with stories enough to fill a book. Those games took entire weekends with the coming and returning back to Chicago. What I always found irritating was that Halas would provide food according to how we had fared against the Packers. If we won, it was steaks for everybody. But if we lost, we were lucky to be served hamburgers.

I had some friends who played for the Packers, but of course we weren't chummy when the whistle blew to start the game. Coach Halas would have had none of that. Green Bay was the enemy. That meant the players, the fans, and the media. You kept to yourself up there and got the job done. If you won, things were real good for a long time afterwards. If you didn't, you just wanted to get on to the next scheduled game as soon as possible and hope that the coaches forgot what you'd done wrong.

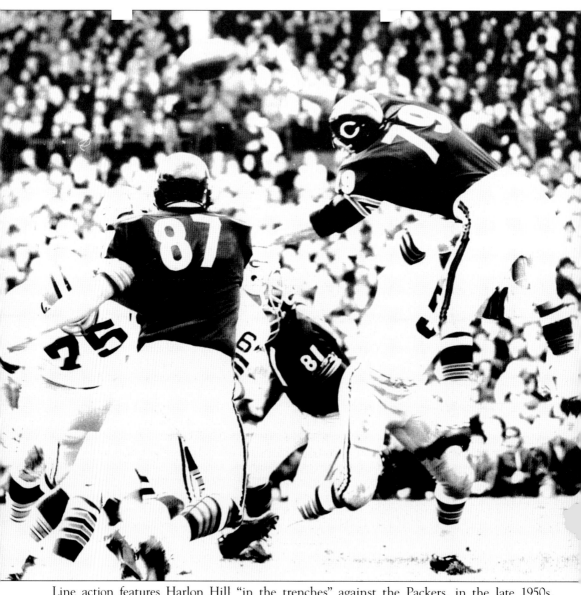

Line action features Harlon Hill "in the trenches" against the Packers, in the late 1950s. (Courtesy of Ron Nelson at Prairie Street Art.)

# Jack Johnson
## 1957–1959

The Frozen Tundra, as Lambeau Field is frequently called, earned its name from the brutal conditions faced by both fans and players. On a deep December day, more often than not, winds would build off of the water and howl through the stadium with startling intensity. Even getting to the games could be difficult, with snow drifts of 10 feet or more accumulating in the parking lot. Such situations were a fact of life for hardened Green Bay residents. For University of Miami graduate Jack Johnson, however, the sub zero conditions were both a shock and a challenge.

Johnson, a skilled back for the Bears from 1957 to 1959, grew up playing grade school and high school football in Pittsburgh, a town never known for its balmy climatic conditions. But after four years at the University of Miami, Johnson found himself quite pleased to be living in the tropics. So much so, in fact, that he almost forgot what winters up north had in store.

Johnson was drafted as the 12th pick of the fourth round in 1957. He was "thrilled" to be joining the Bears, a team whose rich tradition and Pro Bowl caliber players seemed to offer "the best possible chance to make a mark in the National Football League." Johnson immediately thrived in his new environment, getting four interceptions during his rookie year. He felt right at home in Chicago, a city not too different in size than either Pittsburgh or Miami. At least that was the case until shortly after Thanksgiving.

Johnson relates the rest of the story:

> By the end of November, it occurred to me that Chicago definitely was not Miami. It was a great city, but the climate? Not great. Of course it wasn't so different from Pittsburgh where I spent many years. But that time in Miami erased any memories I'd had of what a real winter can bring. I was so happy to be with a good team that I hadn't thought about the cold factor at all. Anyway, I was eager and young, and sure that I could cope.

> What I discovered shortly after it turned bad outside was that Coach Halas fined players for warming up their hands on the sidelines. That meant no gloves. Can you imagine that? It was some sort of a theory he had developed. I was the new guy so I certainly wasn't about to correct him, but it seemed kind of strange to me. By the beginning of December, I was just trying to survive.

> Now Coach Halas was strict under the best of circumstances and in this particular matter, he was not going to be challenged. I believe that his theory was that a player could better grip the ball if his fingers and the pigskin were at comparable temperatures. That's fine if it's October and the weather outside is 50 degrees. But in Green Bay in December, you were talking about below zero wind chill. Completely brutal. I'd be lucky to be able to feel the ball at all.

> In the Coach's mind, this was the way to get proper adhesion between the player and the ball. As a young player, it certainly wasn't my place to disagree with him so I kept my peace. He was notorious for fining for any infraction, and this was also a factor. I followed the rules and did the best I could. I guess it never bothered me too much once the games got underway but standing on the sidelines could be brutal. Some of those contests up in Wisconsin felt like they lasted for days.

> The games against Green Bay were difficult for a number of reasons, weather being only one. There was such intensity in everything that had anything to do with the rivalry. The entire week leading up to the meeting, our coaches would emphasize just what we had to do and how we were going to do it. Losing was not an option. And Coach Halas just wouldn't let things go. He got so fired up. Winning was his life's mission, and he would go to any lengths to beat the Packers.

> This wasn't like preparation for an ordinary game. New plays appeared. Strategies were discussed. It was football at a completely different level. All we'd hear the entire week was "the Packers this" "the Packers that." Over and over, hour after

hour. Frankly, by the time Sunday rolled around, we were so sick of hearing about Green Bay we just wanted the game to start so we could get it over with.

The level of emotion on the field when Green Bay was our opponent was incredible, after all this was a long-standing grudge match. Every player gave that little bit extra. We would do things they wouldn't try in an ordinary game. Questionable plays, clipping, hitting a little harder or a little lower, it was all there.

The refs were pretty good about it. They didn't call the game tighter than any other. If anything I think they gave us some latitude to go at it. That was part of the overall atmosphere. Of course, injures would invariably follow. We all had our share. You'd just suck it up and stay in the game as long as possible.

I learned to protect myself any way I could. My entire body changed once I came to Chicago from Miami. That was one of the ways I was able to handle the physical challenges. In college I played both offense and defense and my weight reflected that effort coming in as a freshman, I averaged around 185 lbs. By the time I graduated, I was at 172.

After signing with Chicago, I realized that the adding bulk to my frame would be necessary. Of course pro players were bigger generally than those you would encounter in college so it was good to weigh more rather than less. But I also found that it really helped me acclimate to the weather and to the intensity of play to have a little more natural padding on my bones. My usual weight when I was with Chicago was for me a relatively hefty 195.

You could always tell how well the Bears had done by the level of noise inside our train cars on the way home from Green Bay. If we'd won, it would be bedlam. Everybody would laugh and sing and have a wonderful time. If we'd lost, however, all there would be was a deadly quiet.

At least when we played in Chicago the aftermath lasted for a shorter period of time. We'd celebrate a win, then go our separate ways. Of if we lost, we'd get really angry, then head out of the locker room. Because of the travel time involved, an away game against the Packer always meant there would be a lot of time to relive what had happened on the field. Sometimes that was good, other times it wasn't.

The fans of course had quite obvious reactions to the Bears-Packers games as well. We were very popular if we won, the toast of the town. If we lost, nobody would be buying us any drinks for quite a while. Interestingly enough, those strong emotions became part of the most difficult transition I've ever had in my life.

As a Bear player in Chicago, and particularly if you've just beaten the Packers, you're a star. But once you leave professional football and enter the world of business, that all stops. There you are going into somebody's office in your white shirt and tie. Nobody knows who you are and nobody cares. You beat the Packers in '58 or '58? So what? It took me a very long time to be able to cope with the loss of adulation that this city heaped on their Bears.

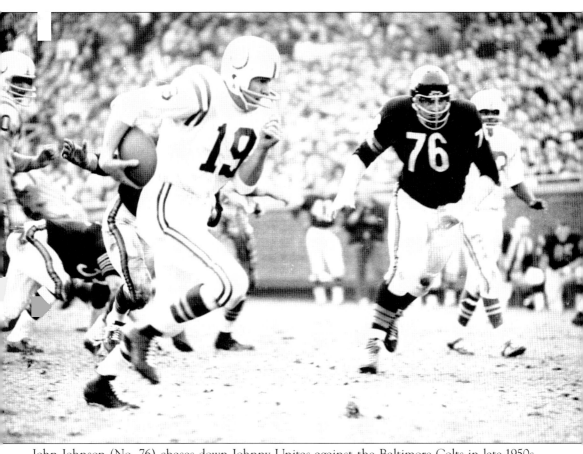

John Johnson (No. 76) chases down Johnny Unitas against the Baltimore Colts in late-1950s gridiron action. (Courtesy of Ron Nelson at Prairie Street Art.)

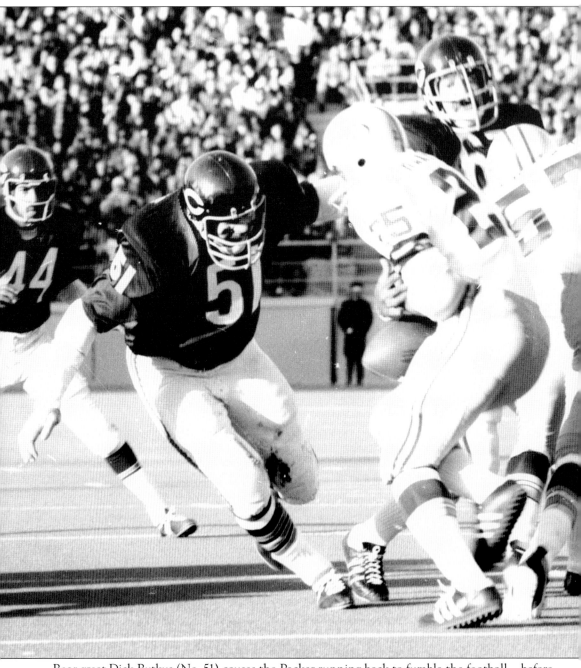

Bear great Dick Butkus (No. 51) causes the Packer running back to fumble the football—before even being hit—while Gary Lyle (No. 44) closes in on the play. (Courtesy of Ron Nelson at Prairie Street Art.)

# Stan Jones
1954–1965

Planning ahead can be a very good thing, as the Bears discovered when they drafted future Hall of Fame player Stan Jones a full year before the consensus All-American tackle graduated from the University of Maryland.

Jones's ability was no secret to NFL scouts. An impact player on both sides of the ball, Jones clearly had the talent and desire to make it as a pro. He was drafted by Chicago in the fifth round of 1953 and eventually joined the team in 1954.

Jones was one of the first in the league to devise a personal weight training routine. At 6 feet 1 inch, and 250 lbs, Jones had the size required for his position, but felt that he could improve as far as strength was concerned.

> *I grew up in Lemoyne, PA, near the factory where York Weights were produced. The company had a center where their products were tested. As a high school student, I'd go in and see all of these athletes lifting. It seemed to be a very effective method and I was quite intrigued by the entire process.*
>
> *At that time, many coaches and trainers at the grade school, high school, college and professional levels feared that if a player participated in weight training, he would become muscle-bound and his agility and speed would be adversely affected. In retrospect, it's difficult for me to understand that attitude. I decided to take that risk. Almost immediately, I found myself to be much more effective on the field.*

Jones continued his fitness routine after coming to Chicago. He refined and expanded his technique after meeting future Bears fitness and strength coordinator Clyde Emerich at a local YMCA. While the two worked out together, they formed a friendship that has lasted to the present day.

He proved to be a durable all purpose impact-maker for the Bears. He started at offensive tackle then was moved in 1955 to left guard where he remained for the next eight years. He also was elected offensive captain. Jones switched to defensive tackle in 1962 at the request of coordinator George Allen. He remained at that position until he left the Bears in 1965.

Jones finished his playing days by signing with the Washington Redskins for one year. He then moved around the league as an assistant coach, working for Denver, Cleveland, New England, Buffalo, and finally, for the Scottish Claymores of NFL Europe where he completed his coaching career in 1996.

To say that Jones had an impressive career in Chicago would be an understatement. Between the years of 1955 to 1961, he went to seven consecutive Pro Bowls, one of the few players of that era to do so. In 1991, Jones was elected to the Professional Football Hall of Fame, an event the former Bear called "a dream come true."

Currently a resident of Denver, Jones looks back on his days of playing against the Packers:

> *When I think about Green Bay, the first thing that comes to mind is that train ride. The length of that trip all depended on whether or not you'd won the game. If you won, then it seemed a brief and delightful journey. If you lost, the ride back home was endless.*
>
> *Getting to and from our rooms was a simple affair, with all of us walking from the train to the Northland Hotel. Then the day of the game, we'd dress at the Northland, eventually gathering together in the lobby. One of the coaches would blow a whistle so we knew it was time to leave. We'd walk to the stadium, play the game, then go through the entire process in reverse.*
>
> *The stadium wasn't much to brag about in those days. It was pretty small with wooden bleachers. Not too many fans could sit there, but Green Bay seemed to pack them in anyway.*

I always felt great respect for the players we faced. Although during the games we'd have been happy to kill each other, once the contest was over, we were friends again. I knew several of the guys who played for a while in Chicago, then were signed by Green Bay. I always put friendship aside for those few hours, then we became pals once again.

The Green Bay fans were never much of a problem. They were pretty polite while we were walking from the hotel to the stadium. Actually, it was the Chicago fans who could cause some trouble if we hadn't won. Being near them was like walking the gauntlet

The Bears players and coaches traveled in cars that were towards the back of the train. If you'd lost, the walk along that entire length of the train was pretty tough. The boos were deafening. You'd hear yourself called some names that you'd just as soon forget. But if we'd come out ahead, it was joyous. We became everybody's heroes.

One trip back to Chicago was particularly memorable. We were underway and comfortably seated in our special section. Coach Halas was sitting near the front going over statistics. We'd lost the game and it hadn't been a particularly impressive outing for Chicago. It was one of those discouraging days when everything seemed to go wrong.

Suddenly there was a commotion near Halas' seat. It seemed that a fan who clearly had too much to drink had somehow made his way into our car. He was headed right at Halas shouting what a lousy coach he'd been.

We got up from our seats ready to tackle the man and get him out of there but the coach stood up and asked the man if he were a season ticket holder. The man replied in the affirmative, saying he'd been attending games for over 20 years. "In that case, you have a legitimate gripe," Halas said. "Sit down." The man did so and we could see that they soon were deep in conversation. When it was over, the fan stood up and said to the coach, "Halas, you're OK," and he left the car. It was the darndest thing.

Green Bay-Bears games were major events throughout the nation. People came from all over to watch us. One time we were on the field. I looked up and there was then Vice President Richard Nixon. Another time I was walking through the Northland Hotel when I saw a large man giving autographs to a sizable group of fans. I waved at him, assuming he was a Green Bay player. Quite a few of them lived in the hotel during the season.

Halfway up to my room, it suddenly dawned on me just who I had seen. It was Jim Arnness, then a big star in the Gunsmoke series. I was sorry I hadn't asked him for an autograph, too.

Although I never minded playing in Green Bay, some of the most enjoyable games for me were those held in Milwaukee. It was a good stadium that was easily accessible for fans from both sides. You had more of a mixed crowd for those games.

Whenever we were preparing to play the Packers, Halas would say or do anything just to get us mad. He was particularly hard on coach Lombardi. He would call him every name in the book. I was sure that he absolutely hated that man.

Strangely enough, the coach's son, Mugsy, came to Denver to go skiing with his wife one time after I'd left the team. We met in Denver and had a great time together. I asked him how it could be that his father hated Lombardi so intensely. Mugsy looked surprised and said. "No, no. They were close friends off of the field. He just wanted his players to believe they were enemies so they would try harder to beat Green Bay." That certainly was a surprise to me.

Stan Jones jogs out from the locker room before the Wrigley Field ivy, around 1960. (Courtesy of Ron Nelson at Prairie Street Art.)

# Rick Casares
1955–1964

As a young sports fan, Rick Casares's favorite football team was the Chicago Bears. Although the dominant running back did become one of the most respected players of his era, lining up for the Bears wasn't always the positive experience Casares had hoped it would be.

"I had a lot of battles with Coach Halas over the years," Casares said recently. "And it wasn't about the records or things like that. Rather, it was the fact that I never felt an owner should also function as a head coach and I told him as much. That's a faulty system with no checks and balances. Halas never had anybody he had to answer to."

Casares joined the Bears in 1955 after a notably successful four years at Florida. During his rookie season, Casares led the league with an average of 5.4 yards per carry and rushed for 672 yards, the second highest total to that date in Bears history. He was an all-around player whose agility, speed, desire, and intelligence made him a favorite of Bears quarterbacks and a target for defenses throughout the league. Although a modest Casares credits the skills of his offensive line for much of his eventual success, many opposing players might disagree.

With a total of 1,126 rushing yards in 1956, Casares fell just 20 yards short of the league's all-time record in a season, a fact he was unaware of at the time.

> I was taken out of the last game with about six minutes to go. I didn't think much about that at that moment, but after the game assistant coach Phil Handler came running up to me apologizing for the fact that I wasn't given the opportunity to stay in and break the record. I was astounded. I had no idea I'd been so close. All I thought about during games was just getting the downs.
>
> I never kept track of records, but in retrospect, I realized what Halas had done. He didn't want any members of his team getting too famous. That would have meant he'd have to raise their salaries. Halas was completely money driven in that sense. Later on, people would come up to me and say that one game could have insured my entrance into the Hall of Fame but frankly, I have no regrets. Being in the Hall would have been nice, but winning the games was all that I ever wanted. That goal was accomplished.

Halas's tight rein on his players extended to any and all publicity they would receive even during the off season.

> I had a great offer from a prominent sports magazine before the start of the 1957 season. They wanted to put me on the cover with the title "The New Monster of the Midway." That was until the Coach found out. "No way," Halas said. "Casares can be featured only if there are other players pictured on the cover as well." So that's how it wound up, me next to Stan Jones and Bill George. I didn't mind at all because I respected those two players and was glad to see them honored, but it was just another indication of how Halas had to be in charge everything.

Casares still blames the Bears mediocre 1957 season on Halas's need for complete control.

> Coach came back from retirement that year. We had been picked before the season began as a sure thing to take the league championship. Unfortunately, Halas just couldn't abide Ed Brown so he took him out in favor of Zeke Bratkowski who wasn't half as good. Bratkowski couldn't get the job done so Halas then alternated him with Brown. It was a fiasco.

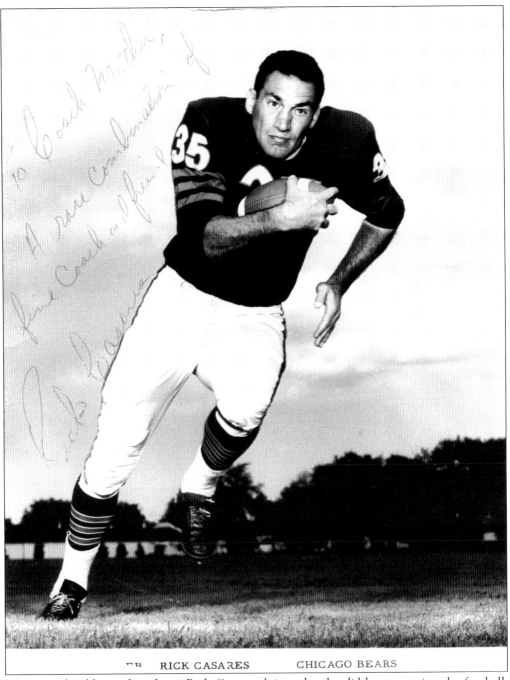

RICK CASARES　　　CHICAGO BEARS

This signed publicity shot shows Rick Casares doing what he did best, carrying the football. (Courtesy of Coach Mather.)

Looking back, Casares remembers the games against the Giants and Detroit as the toughest he experienced during his years with the Bears, but he also vividly recalls the emphasis Halas always put on the contests against Green Bay:

*Even if you didn't look at our schedule, it was easy to tell when Green Bay was coming up. Halas' intensity would increase by the day. He never wanted to lose. Heck, none of our team could abide losing, but get him on the field in Lambeau or in Wrigley with the Packers on the opposite side, and he'd go crazy.*

*Green Bay at that time was known league wide for its power sweep. That was Lombardi's bread and butter play. This was incredibly difficult to defend because it tended to spread out the line. Hornung would just tuck in there and run all over the team on the other side of the ball.*

*That's where I give all the credit in the world to Joe Fortunato and Bill George. Fortunato would take out the lead guards and George would make the tackles. Nobody could get by them. Just ask the Packers. They were incredible players who, in my opinion at least, far outshone Ray Nitschke in the talent department although Nitschke had much more fame.*

*Nitschke was a strange guy, kind of a thug at heart. He had great football instincts and he was respected by his teammates, but nobody ever liked him very much. They all wanted him on their team, but it was rare for a Packer player to ask Nitschke out to dinner once the game was over.*

*Nitschke was what I termed a "clean up player." That was another term for "bully." He'd hit you after the play was over while two of his teammates were holding you down. Things like that were completely inexcusable. How he got away with it so often is beyond me. It was nothing but dirty play from my point of view.*

*The culmination came when Nitschke broke my ankle in the November 17, 1963 game against Green Bay. Two other guys grabbed me and Nitschke made his move down low. The ankle just snapped and put me out completely. Even though I had some good football ahead of me, I never forgave him for that.*

*Some months after that game, I ran into Nitschke at a charity dinner held at Fuzzy Thurston's restaurant in Green Bay. The least I expected from him was some type of an apology. That wasn't what happened. He took me aside and made an inappropriate remark. My inclination was to smash his face in right then and there, or at least to ask him to step outside where we could finish things. But having been in the restaurant business myself, I didn't want to cause any problems for Thurston so I let it go. I never forgot or forgave Nitschke for what he did to me.*

*I did have a close friend on the Packers team, though, Paul Hornung. We'd met at a Pro Bowl and hit it off immediately. We were like two peas in a pod. Although we never were friends on days when the Packers and Bears played each other, once the games were over, it was all fine again.*

*Paul and I loved the nightlife and enjoyed experiencing opportunities to the fullest. We partied wherever our travels might take us, in just about every city in the country. But that was the way things were then. Many other players did exactly the same thing.*

*Paul's mother was a wonderful lady. She was my "date" at a big Las Vegas opening one time and we had a ball. During our playing years, Horning and I went to nightclubs, restaurants, and met countless celebrities. We'd stay up all night and sometimes get into a little mischief. It was a different lifestyle back then and we were the prototype of the hard playing, hard living football players. But it was all in good fun and our friendship still endures.*

*The only time I ever turned Horning down was if he'd call me after a Bears loss. I didn't care how good the invitation was, after a loss, I wanted to be by myself.*

Most of our team didn't take things that hard, but I certainly did. If I didn't win, I didn't want anybody around me. I just wanted to be alone and think about things.

Looking back now I'm grateful for all of the experiences both good and bad. The career I enjoyed was far beyond any hopes or expectations I might have held as a young athlete. I relished the camaraderie and the competition. I loved giving everything to each game. There are few experiences in life that can compare to my years with the Bears.

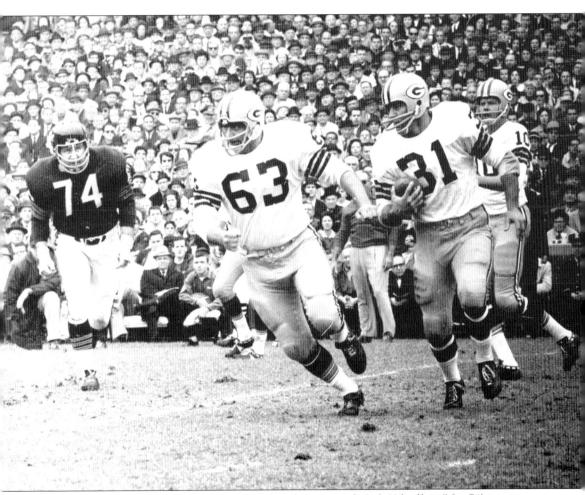

Paul Hornung carries the ball against the Bear defense, with Bob Kilcullen (No. 74) in persuit. (Courtesy of Ron Nelson at Prairie Street Art.)

# Chuck Mather
1958–1965

Chuck Mather served as the Bears offensive coordinator from 1958 to 1965. Before joining the Bears, Mather was a nationally known high school coach at Washington High School in Massillon, Ohio, and a former head coach at the University of Kansas.

Mather came from a part of the Midwest known as the Cradle of Coaches. One of his earliest coaching associates in Ohio was Paul "Bear" Bryant, a man who would become a lifelong friend. Although Mather never played any high school football and only suited up for a total of three games in college, he was able to grasp the techniques of effective coaching instinctively. Then, as now, the key to success in football hinged on the savvy use of strategy and motivation, and on tailoring a game plan to maximize players' strengths and unique abilities. At Massillon, Mather's six-year span brought national attention as the school compiled a 57-3 overall record and six straight Class A State Championships. After leaving Massillon, Mather formulated what he had learned there into a best selling book, *Winning High School Football*, which was used as a college text throughout the country.

Mather was never afraid of innovation and had the ability to find advantages in untested methods. He was one of the first coaches in the country to utilize IBM cards in statistical analysis and to use television to view his team's games. Much of his eventual success came from this combination of a basic knowledge of the game combined with his own unique touch. Mather's first coaching position was in Brilliant, Ohio, where he worked with players most of whom had never experienced the game. Building such a team from scratch was a formidable challenge and often required unorthodox techniques:

"It was a different era," Mather recalls. "This was during the Depression and materials were hard to come by. People learned to take what was at hand and make do. The practice field we used wasn't anything special, just an open area that we had to clean up before the players could begin their drills. The vital piece of equipment that we were lacking was a goal post. It's pretty difficult to have a good practice or hold a game without uprights."

Luckily, a sizable lumber yard was located not far away.

*We'd "borrow" two-by-fours and take them to the end zones. Then we'd construct what we needed to play. When the game was over, the lumber yard people would come and take back what was rightfully theirs.*

Mather watched and strategized as his new players learned the game.

*Coaching in Brilliant was where I developed my overall coaching philosophy. It continues to this day. I didn't like my players to go straight through the middle. That's where the biggest and strongest defenders were. Instead, I liked a wide left or a wide right. That's the approach I used in Massillon, at Kansas, and with the Bears.*

While with the Bears, Mather was one of the first to recognize the importance of an established strength and conditioning program. He met future Bears strength and conditioning coordinator Clyde Emerich at a Chicago YMCA through Stan Jones, one of the Bears' top players.

*Stan and Clyde and a few of the other Bears used to lift weights together quite often. At that time, there was a certain fear in all levels of football that a muscle-bound player would be a slow player. What many coaches didn't realize was that good conditioning would actually help speed and also protect against game incurred injuries. When Clyde was hired, he developed the prototype for the Bears strength program. It wasn't too long before other organizations noticed our success and brought a similar regimen to their own players.*

Mather still enjoys periodic reunions with his players from Massillon, Kansas, and the Bears. Even 40 years after the Bears' 1963 championship season, his former players in Chicago still speak fondly of the man they call "the Coach."

For Coach Mather, as for all of the Bears personnel, the games against Green Bay were the lynchpin of a competitive season. Extensive preparation was required, often far beyond what was utilized against other teams. But Mather took the supposed "hatred" between Halas and Lombardi with a grain of salt:

> George would rail out there on the sidelines whenever we met Green Bay. He'd pace back and forth muttering or shouting. You'd think that Lombardi was his worst enemy and at that particular moment, he may well have been. But off of the field, I believe that the two men had a deep and abiding respect for each other.
>
> Lombardi himself had been through the coaching ranks and I think that because of that, he understood Halas quite well. George was the pinnacle of coaches at that time. He had been there from the beginning and had kept the league viable when its foundations were shaky. Lombardi respected that history.
>
> I think that as a coach Halas saw what Lombardi was able to do with his players and admired the results. The Bears always gave 110 per cent against Green Bay and the reverse was true as well. These games were almost like a chess match with two wily men matching wits and skill.
>
> The train ride to Green Bay always added something to the mix, or at least that was the way I saw things. The energy would build until we arrived at the station and make the trek over to the Northland Hotel. The scene there was often chaotic with fans of both teams wandering everywhere. Parties would go on outside our windows until late at night. Our theory on that was that Packers supporters wanted to be sure that the Bears would get to the game with a minimal night's sleep.
>
> Game plans were pretty basic. There is only so much you can do. But both head coaches often saved something a little special just for these particular meetings. Sometimes that worked, other times it didn't. Halas would get so riled up on the sidelines that I'd try to balance things out by being calm. I didn't think we needed any more emotion in those situations.
>
> The weather could be rough, but after playing in Chicago, our team was as accustomed to being cold as the Packers were. Sometimes it could get brutal. The championship game at home against the Giants in 1963 had the worst conditions I can remember. But some of those days in Green Bay and Wrigley Field weren't much better.
>
> Coach Halas had a theory that the players could hold the ball better if they didn't use gloves. That was a far cry from today's techniques when just about every player on the filed has gloves on his hands no matter what the weather might be. Often times, the players would use rosin just to get a good grip. By the end of the game, the ball would be an incredibly sticky mess.
>
> During the run of 1963, we knew before the season ever began that the games against Green Bay would be pivotal. There was no margin for error that year. Green Bay had been champions and as far as Halas was concerned, there was no way he'd let that happen again. We were able to get them both times and go on to take the championship. I'm not completely certain that our players were any more excited after taking that trophy than they were each time we beat Green Bay.

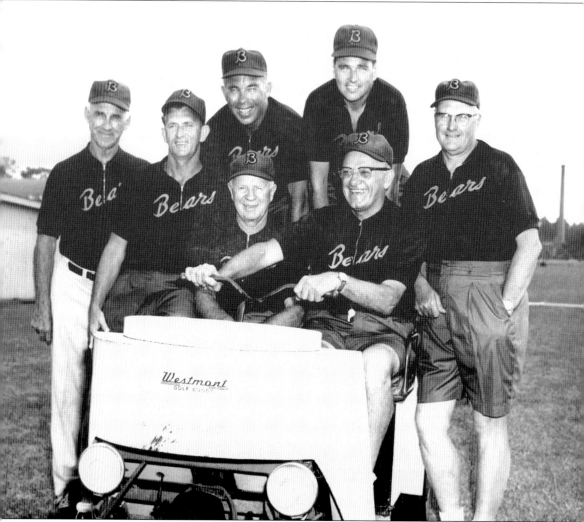

The Chicago Bears' coaching staff is seen here relaxing, around 1963. (Courtesy of Coach Mather.)

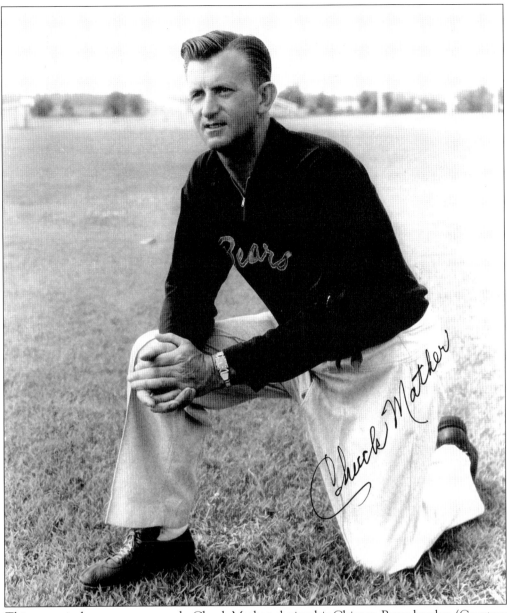

This portrait shows a young coach, Chuck Mather, during his Chicago Bears heyday. (Courtesy of Coach Mather.)

| DATE | AMOUNT |
|---|---|
| hare-1963 Champ. Game | |

CORRECT PLEASE RETURN. NO RECEIPT NECESSARY

THE NATIONAL FOOTBALL LEAGUE
1 ROCKEFELLER PLAZA
NEW YORK 20, N. Y.

3997

JAN 28 1964 19____ 1-12/210 110

PAY TO THE ORDER OF        CHARLES   V.   MATHER        $ 5,899.77

THE SUM OF 5899 DOLS 77 CTS        DOLLARS

CHEMICAL BANK NEW YORK TRUST COMPANY
10 ROCKEFELLER PLAZA
NEW YORK

AUTH. SIGS.

⑆ ⑈0 2 10 ⑉00 1 2⑈: 1 10 ⑉00 6 7 39 ⑈

Payday! This was a coach's championship share from the victorious 1963 campaign.

# Bill Wade
1961–1966

Quarterback Bill Wade was a seasoned veteran when he came to the Bears after seven years with the Rams. Although Wade was quickly informed by the Bears coaching staff that he would be expected to lead Chicago to victory any time the Bears faced Green Bay, he wasn't particularly intimidated by the prospect. By his own admission years later, Wade hadn't kept close tabs on the fierce rivalry between the two Midwestern football pioneers and didn't realize the extent of ill will on both sides.

"I came here from California and I grew up in Tennessee," Wade said recently. "Naturally having been part of professional football for some time by the time I joined the Bears, I knew that Green Bay and Chicago didn't care too much for each other. But what I didn't realize when I first moved to Chicago was that even if either team ended up with a losing season, the year was considered a success if they had beaten Chicago or Green Bay."

During his six seasons as quarterback for the Bears, Wade would taste defeat more than victory over the Packers. Chicago only came out on top over Green Bay a total of three times, notching two vital victories during the 1963 championship season and one more win by a score of 31-0 at Soldier Field on Halloween in 1967.

However, Wade still ranks seventh in all-time passing yardage for the Bears with 1,407 attempts and 767 completions for a total of 9,958 yards. While with the Bears, Wade was known for his durability, his agility, and his competitive nature. In 1963 alone, Wade scored five rushing touchdowns. He was a two time Pro Bowler, entering that game's starting lineup in 1958 and in 1963.

A Tennessee native and a product of Vanderbilt, Wade was drafted by the Rams in 1954. While there, he first met future Bears assistant coach George Allen, a man Wade would later characterize as "one of the major influences on my playing abilities and overall knowledge of the game."

One of Wade's and Allen's final meetings would occur when Wade was offered a job with the Bears as quarterback coach in 1967, shortly after he retired from playing. Seeing himself more suited to a possible head coaching job and feeling that Allen would be offered that spot by George Halas should the head coach retire, Wade left football and relocated to Nashville where he still resides.

As Wade reflects back on his days with the Bears, he remembers the importance to the team of winning against Green Bay:

> Coach Halas was always out to get that team from the north. He often characterized them as "cocky and smug." It was a matter of pride for him, this rivalry that had gone back to the early days of professional football. First there was Halas against Lambeau, then Halas against Lombardi. No matter who was coaching the Packers, Halas wanted to win in the worst way.
>
> During training camp before the start of the 1963 season, Halas was even stronger on that subject than usual. He'd had some kind of a dust up with Lombardi at a party in New York during the off season. I heard that Lombardi had made the mistake of telling Coach Halas that the Packers would have no problem getting the championship during the upcoming season. As you can imagine, that didn't sit well with the Old Man.
>
> Halas and his assistants began working on game plans for the Packers well before we came to camp. It was that important to him to beat Lombardi. Once camp began, we'd have designated times to go over these plays but we were told that we were not to use them any time other than when we were facing Green Bay.
>
> Mike Ditka used to stay after practice going through routes for hours. He was a quick learner and a fighter. Clearly, he was one of our most powerful offensive weapons. Johnny Morris, Ronnie Bull, all of those guys on offense really put their

heart into these practices and later into the games. Green Bay was said to be fielding a strong team in 1963 so we knew we had to be at our best to get them.

Our defense was told to keep us close enough to pull out a win. There again, we fielded a strong team filled with players who are now Bears legends. The 1985 team had a tough group of guys but I think that ours was their equal. We knew that if the Packers could find any weakness in our lineup during a game it would be hard to come back against them. We had to be good enough to never let them get away from us.

Although my overall record against the Packers wasn't the best, we did prevail in both games that 1963 season. It was a wonderful feeling, almost as if we had already won the championship. This was a goal that we had worked for, had dedicated ourselves to. I think that these two wins in particular helped build and sustain the momentum that carried us all the way through the post season.

In 1965, we had just the one win against Green Bay, although personally I think that we could have won both times we faced them. Things didn't go our way though. A rookie at that time, who I won't name now, did something he shouldn't have and ended up losing the game for us. Those things happen in football. You just try to forget the outcome and go on.

I enjoyed being coached by Chuck Mather. He was always looking for an edge over the Packers. He'd send Ditka on one route and Morris on another, mixing things up a little. It would be confusing to the defense, even one as powerful as Green Bay's. Chuck felt that since we had so many offensive options, it was best to utilize them as often as possible.

In 1963 we knew that the Packers scouted us heavily, that they, like us, would do anything to win. But with players as talented as we had on our roster that year, it was nearly impossible for Green Bay to shut us down.

There was a way around Green Bay's trying to steal our plays. Coach Halas, Coach Mather and Coach Allen always tried to come up with a few trick moves that the Packers hadn't seen before, that weren't in our regular play book, just to throw them off their stride a little. This approach was usually pretty successful.

Green Bay during those years had such strong teams, talented guys who played hard particularly when they were at home. They could get cocky at times, but we could be that way too. The crowds really got their players going, just like ours did when we faced Green Bay at home. Contests between the teams were never tranquil affairs. Feelings among the players from these teams ran high. There were some harsh words exchanged before, during and after the games.

Looking back on these games from today's perspective, though, I try to see things from an objective point of view. My record against Green Bay wasn't what I had hoped it would be but it isn't something I can change now. It was a job after all, one that I tried to do well. Sometimes winning or losing is beyond your control.

But overall, I feel at peace when I remember these contests. There's something honorable about giving your all and that was always what happened when these two teams met.

Coach George Allen paces the sidelines along with the Bear mascot. (Courtesy of Ron Nelson at Prairie Street Art.)

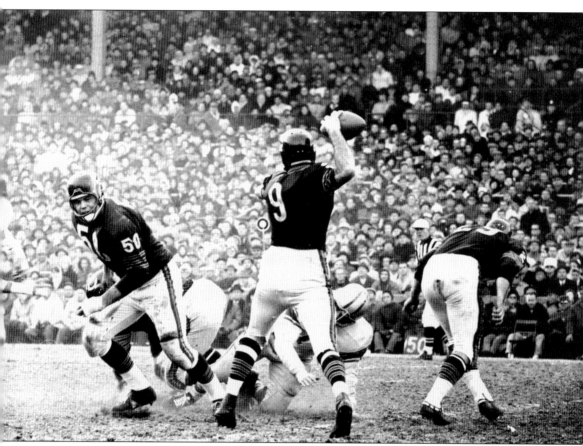

Mike Pyle (No. 50) protects quarterback Bill Wade during the 1963 season—a Pro Bowl campaign for both. (Courtesy of Ron Nelson at Prairie Street Art.)

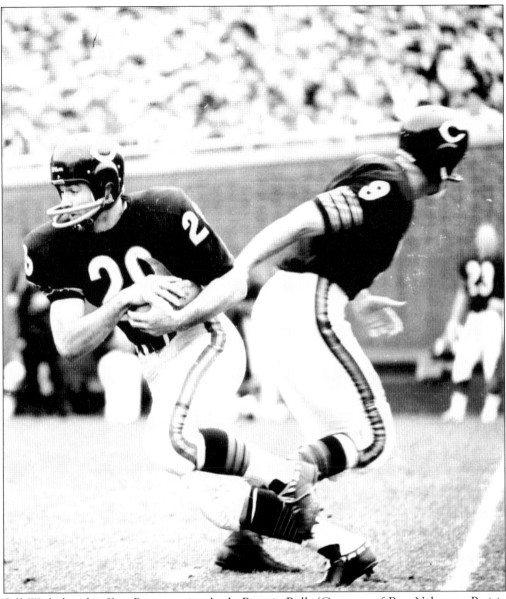

Bill Wade hands off to Bear running back, Ronnie Bull. (Courtesy of Ron Nelson at Prairie Street Art.)

Bear offensive linemen push the practice dummy as they warm up for Green Bay. (Courtesy of Coach Mather.)

The Bears J. C. Caroline (No. 25) and Dave Whitsell (No. 23) push up against Green Bay blockers, including Ray Nitschke, in an attempt to block a kick for extra point. (Courtesy of Ron Nelson at Prairie Street Art.)

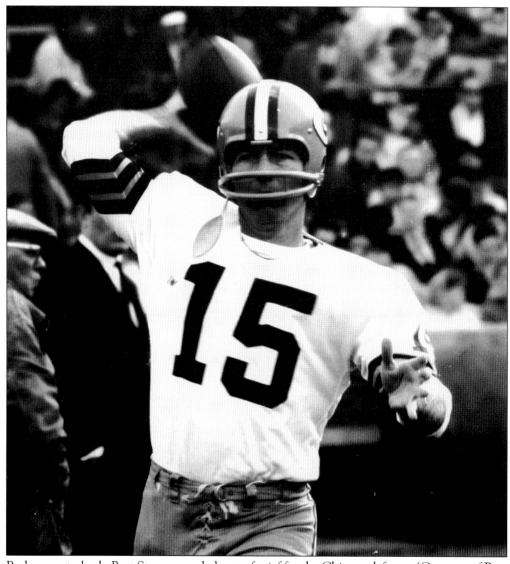

Packer quarterback, Bart Starr, caused plenty of grief for the Chicago defense. (Courtesy of Ron Nelson at Prairie Street Art.)

# Doug Atkins
1955–1966

Growing up, eight-time Pro Bowler and Hall of Fame defensive end Doug Atkins always pictured himself becoming a professional basketball player. Reaching an eventual six feet, eight inches, and 275 lbs in high school, he certainly had size in his favor. His skill won him a scholarship to the University of Tennessee where he also excelled in track and won the division's high jump championship.

Bob Neyland, who at the time was the University's varsity football coach, happened to see Atkins practicing for track one day and was stuck by the youth's agility and speed. Realizing that Atkins had tremendous potential to be an impact maker on the gridiron, Neyland recruited Doug to join his defensive unit. Atkins reluctantly agreed as long as coach Neyland would allow him to continue with basketball as well.

Atkins's defensive production for the Vols was impressive enough that he was drafted in the first round by the Cleveland Browns in 1953. Still stubbornly clinging to his hoop dreams, Atkins also signed with the Detroit Vagabonds and played as a pro until Weeb Eubanks convinced him that true destiny would be found on the football field, not the court.

Atkins thrived in the nurturing environment provided by the Browns and was an invaluable part of the team as it won the division title in 1953 and the league championship in 1954.

After leaving the Browns in 1955, Atkins joined the Bears where he would remain for the next 12 years. He quickly became an impact player, winning all-NFL honors and a slot at DE in eight out of nine years.

His skills were never more evident than during the hard charge to the league championship in 1963. Atkins seemed to delight in striking terror into the heart of one opposing quarterback after another while never allowing opponents to score more than 10 points a game. Atkins was again pivotal as the Bears put a damper on the heavily favored Y. A. Tittle and the New York Giants in a 14-10 upset to gain the title.

Atkins's years in Chicago would prove to be both a productive and a tumultuous time for the young DE. Rumors of supposedly wild extracurricular exploits flew through the sports pages and often threatened to overshadow his production on the field. A very public and ongoing feud with coach Halas added fuel to the fire and at times threatened to break Atkins's concentration on the job at hand. But when it came time to play the Packers, Atkins was always all business.

Although Atkins moved to the New Orleans Saints in 1967 where he finished out his career at the conclusion of the 1969 season, he always remained the prototypical Bear at heart. A hard working, hard living player, Atkins still is viewed as a legendary part of Chicago sports lore. And, long since retired and living in Tennessee, he still enjoys reliving the games against Green Bay:

> So much has been said about the years I was with the Bears and frankly, a lot of what you'd hear or read was just untrue. The sportswriters would say this or that, anything they felt would make a good story. But the end result didn't always equal the facts involved.
>
> If I had any faults, I guess it would be that I was a passionate player. I wanted to win. Heck we all did, I probably was just a little more obvious about that. The other thing that I'd keep hearing was that Doug wasn't a practice player. People would claim that I'd dog it during the week just because I was lazy or out of sorts, then I'd play enough on Sundays to get by. This couldn't have been further from the truth.
>
> In those days, teams weren't as large as they are now. They just didn't have any reserve players to speak of, so if you went in you stayed in. Treatment of injuries was so different then as well. You got hurt, they'd give you a shot and send you back on the field. These doctors and trainers didn't have to stay up all night after a game just trying to move from the bed to the door. Sometimes it was so painful afterwards, I could hardly walk. That was no fun. So my philosophy became one

of getting by as best I could. I'd save myself for the games. Otherwise my career could never had gone on as long as it did.

Thinking back on Green Bay, I guess I remember things quite differently than the way most of the fans would. For those on the outside, rivalries such as the Bears and the Packers are entities of themselves. They take on a life of their own. These people want you to win just to say we've beaten the Packers.

Well, that's fine and I certainly don't have any argument with that view, but from a players' perspective, things seem quite different.

In practice before going against Green Bay there would be a raised intensity. All week leading up to that game would be somewhat different. The coaches were more intense, the players more driven. So, yes, there was definite anticipation that was more than you'd find during an ordinary week.

But for me at least, once game time arrived, it was just a job the same as any other week during the season. It was business as usual. I went out there, took my position, and blocked the best that I could. I wanted to win against the Packers. But then, I always wanted to win.

I didn't have any particular grievance with any of the Packer players, I just wanted to beat them all. We'd get in our defense then change things around at the last second just to confuse them. Coach Halas wasn't always on the best of terms with our defensive coordinators, so often times even he didn't know what we were going to do.

What I remember best were the physical circumstances of the game. Those old wooden bleachers in Green Bay before the new stadium was built. The crowd was so close to the players. You'd always hope they weren't going to be throwing things at you.

And Wrigley Field, always a noisy place during any game, but when Green Bay was in town, it would get crazy. Most of the time I was concentrating completely on the plays, but it was hard not to notice the increased reactions of the fans.

The most fun was the trip to and from the game. Unlike today, you always went by train. It was just long enough of a trip to get really comfortable. The Bears players tended to gather in packs while we were traveling. It was natural, you'd always want to be with your best friends on the team. We'd sit around and relax, telling tales and having fun. It didn't get serious until we were getting close to game time, then there was no more fooling around.

Coming back on the train was memorable to say the least. Coach Halas would always try to keep us confined to two or three cars on that train. That never worked. The cars were packed with fans form one end to another. We'd sneak off when Halas or one of the other coaches weren't looking and sit down with friends or strangers. We'd share some beers and have a great time. It was much more difficult when we lost of course, but that ride home was still enjoyable. It was old time football at its best.

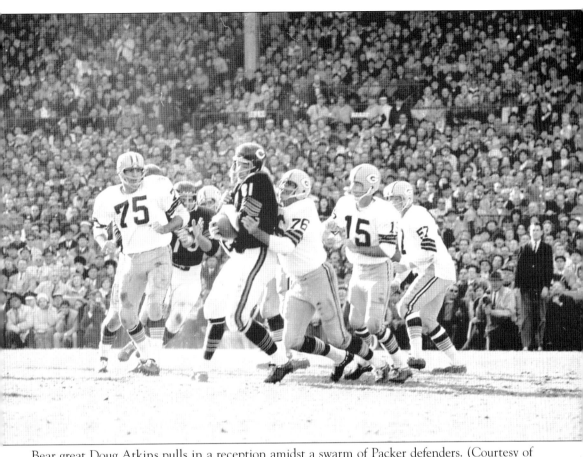

Bear great Doug Atkins pulls in a reception amidst a swarm of Packer defenders. (Courtesy of Ron Nelson at Prairie Street Art.)

# Johnny Morris
1958–1967

Johnny Morris always understood the importance of beating Green Bay, but never more so than during the 1963 championship season. Like the rest of the team that year, Morris was out to dominate every team Chicago would face, but one opponent stood out among the rest. As defending league champions, the Packers were clearly a "must win" situation. Without a clean record against Green Bay, Chicago's chances for post season play would be slight.

The Packers were a formidable opponent coming into the 1963 season. With only one loss during 1962, Green Bay was more than ready to continue cutting a wide swath through their division on the way to still another championship. Coach Lombardi has said as much to George Halas when the two met at a New Year's party in New York City.

"That's all it took to send Halas completely over the edge" former offensive coordinator Chuck Mather would say years later. "George came back to Chicago and called us all into his office. He was livid, shouting and throwing things at the wall. There was no way he'd allow us to lose to Green Bay in 1963."

The Packers had beaten the New York Giants the league championship in 1961 by a lopsided score of 37-0. During the regular season in 1962, Green Bay outscored their opponents by an impressive 415-148 points. Their most decisive win came when they met the Bears, as the Packers got seven touchdowns against their hated rivals.

When it came to the 1962 championship game, Green Bay once again faced the Giants, this time coming out on top over New York by a score of 16-7. They seemed unstoppable and clearly headed for a third consecutive title unless their opponents could come up with some quick solutions. Halas, for one, was certainly more than willing to try.

> Green Bay had been strong for quite a few years, and unless we really knuckled down, 1963 might be no different. Heck, in 1962 the Packers got us 49-0 in an away game and 38-7 at home. That was humiliating and an experience that nobody on the Bears wanted to repeat. That's why the coaching staff approached the season with a new plan. One day a week we'd practice for Green Bay, and only for Green Bay. It didn't matter who we might be facing on any given Sunday, the Packers were always on our minds.

By 1963, Morris was one of the Bears' more experienced and formidable veterans. He starred as an impact player, both during 1963 and throughout his 1958 to 1967 career with Chicago. Known for his agility, his football instincts, and his blazing speed, Morris was a master of deception, more often than not leaving his defenders yards behind on crucial plays.

He remains today at the top of several Bears All-Time lists with a total of 356 catches for 5,059 yards and 31 touchdowns. But no statistics compiled during his playing years were more important to him than his role in helping the Bears reach the championship game.

Always the optimist, Morris was certain at the beginning of the 1963 season that Chicago could find a way to stop Green Bay. Conversations in the locker room and in practice well before the season began soon convinced him that every teammate was in agreement on the matter.

> We went in that year knowing that each of us had to play to the utmost of his ability, maybe even beyond that level. It would have to be a coordinated team effort with no margin of error. We were of one mind on this. That's the only way we could succeed.

Even now, years after leaving professional football, Morris still remembers what it was like to play for Chicago that season:

> What I recall most vividly was the power of the Bears' defense. They were what all the talk was about, and justifiably so. We had some incredible players in the lineup, Rosey Taylor, J. C. Caroline, Richie Petitbon, John Johnson. They knew that their

job was to hold the opponents to as few points as possible, then our offense would take it from there.

But the offensive side of the ball was more than a little impressive as well. The roster looked like a Hall of Fame list. Ditka, Casares, Wade, Bull, Pyle, Galimore, Marconi, Farrington, Stan Jones. We knew that we were able to make quite an impact, too, if given the chance.

Our first game of the season was in Green Bay. It was crazy to go up there. It seemed that the fans would come up with about anything they could think of to throw us off balance. The hotels were legendary. A good night's sleep? No way. People would go up and down the corridors knocking on our doors. Phones would ring at all hours. Or they'd stand outside and shout up at us all night long. Of course we expected that coming in as it happened every single time we played there, but it was still somewhat unsettling.

It was a hard fought game but we came out on top 10-3, which started the season exactly the way we'd wanted to. We viewed the outcome as proof that our approach to things that year worked pretty well. Winning there also gave Halas the opportunity to gloat a little. He always enjoyed facing Lombardi on his own sidelines and beating him. And, the win gave us good momentum to carry on into the rest of the season.

The next time we faced the Packers was later on, week ten, this time at home. Again, we were able to come out on top. This time the score was 26-7. How did we accomplish that? Through dogged effort. Green Bay in 1963 was certainly not a team to be taken lightly.

We were well aware exactly what we were up against. Their linebacker, Ray Nitschke, had been named MVP of the championship game in 1962. He was only one of many stars that team had. There were Pro Bowlers all over their roster.

Their lineup read like that of a Hall of Fame team. Boyd Dowler, Max McGee, Ron Kramer, Elijah Pitts, Bart Starr, Zeke Bratkowski. Everybody who knew football had heard of those guys. There was no way we'd be able to beat them unless we played all out. Green Bay was only half a game behind us. If we lost to them, we'd be out and they'd be on the way to another championship came.

It was a sellout crowd that day, with Wrigley Field probably holding many more fans than it was designed to accommodate. The game was such a big thing in Chicago that 400 fans chartered a train to go to Galesburg. That area was beyond the television blackout zone.

J. C. Caroline was a player I remember most from that second game against Green Bay. I've never seen anyone as fired up as J. C. was that day. He came out of the locker room ready to go. Just went right in and knocked one of the Packers out cold on the very first play. It went well for us from there. Big plays, time after time, most of them in the Bears' favor.

Rosey Taylor, Casares, Coia, Farrington, LeClerc all played like they were possessed. There were interceptions against Green Bay, and a relentless, unending Bears drive from the first minute of play. Everybody came on the field ready to give it their all.

Although they did finally get a score early in the fourth quarter, the Packers couldn't get any solid momentum going. From that first play through the final minutes, we felt certain that we could win. As the clock was winding down, the fans were going crazy. The players were shouting as well. For us it was like a championship victory. Noise tended to build fast in that stadium, but that day was one of the loudest things I'd ever heard at Wrigley.

We still had four games left during the regular season that year, but for many of us, beating Green Bay twice after such a dry spell told us that we could go all the way. I remember that game even now when I look at my championship ring. It was one of the highlights of my career.

Doug Atkins (No. 81), Johnny Morris (No. 47), Ed O'Bradovich (No. 23), and Dick Evey (No. 74) with their teammates await kickoff at Wrigley Field. (Courtesy of Ron Nelson at Prairie Street Art.)

A wide open Johnny Morris looks for the pass in the end zone versus the Packers. (Courtesy of Ron Nelson at Prairie Street Art.)

# Maury Youmans
1960–1963

Tackle Maury Youmans came to the Bears in 1960. As a veteran of the 1959 Syracuse University National Championship football team who also participated in the 1960 College All-Star game, Youmans came well prepared for life in the pros.

Youmans first played in Chicago, then moved on to Dallas, eventually retiring after six seasons in the NFL. Although he was on the Bears active roster only through the conclusion of 1962, Youmans's keen sense of observation served him well. His memories and those of his teammates ultimately led to Youmans's recent book, '63, a work about that year's NFL championship run. Youmans still remembers the intensity of Bears-Packers contests and professes enduring respect for his opponents as well as for his former teammates:

> What can I say about the Packers who played during the Forrest Gregg era other than that they were big, tough, mean players who thrived during hard fought games? Their overall record at that time was somewhat up and down, but whenever they met the Bears, the Packers always looked pretty good. Green Bay's team seemed to turn on an extra effort just for us. You didn't want them angry at you, that was a given.

> As for the rivalry as a whole, what I felt most of all was a discernible level of mutual admiration. There was a fierce competitiveness and that overwhelming desire to win at all costs but once the game concluded, you knew that you had experienced something unique. Players on both sides of the ball were constantly aware of that fact.

> Between 1960 and 1962, the Bears had only one win against Green Bay. It was the first away game of the 1960 season for us that year. I remember that Coach Halas was beyond angry any time his team couldn't beat those guys. He was so competitive but even more so when we faced the Packers. He'd felt that way ever since the rivalry began. As a player you'd always expect particularly intense preparation leading up to those contests. Emotions usually ran pretty high. The Packers were out to get us, and visa versa.

> Things turned around for the Bears during the championship run of 1963. Halas really had it in for Lombardi that year and made it very clear to all of us that we were expected to get revenge for previous losses. That the Bears were in fact able to come out on top of Green Bay twice that year was pivotal in our ability to reach the championship game. Each time we met in 1963 both teams left all that they had out there on the field.

> Bart Starr was indescribable when he played. He often seemed to be more of a magician or a miracle worker than a normal football player. What he was able to do out there could be completely demoralizing for his opponents.

> We'd see him in the darndest situations, caught in numerous third and longs with no chance to get to the first down marker. But suddenly there he'd be getting the yardage they needed. How could you defend against that level of skill? This must be what today's players come up against when they are facing Brett Favre. Natural talent of that caliber is pretty difficult to comprehend and even harder to control from the other side of the ball.

> I always felt that games against the Packers were fair contests. By that, I mean everyone was there to play old fashioned hard mouthed football. You prevailed on strength and ability. The best team usually won. I think that the fans who were there also saw things that way.

> When we were on the road against the Packers, the crowds could be pretty hard on us both before and during the game. But once it was over, everybody understood and appreciated the level of intensity and effort expended. It was such a different atmosphere from what you tend to encounter in stadiums today. There was a closer relationship between fans and player, and much more mutual respect both on and off the field.

I definitely enjoyed the times we faced the Packers in Milwaukee. That was more of a home crowd for us, as it was closer to Chicago than it was to Green Bay. Also the amenities there for the players were pretty good. I know that the fans enjoyed those games. Bears supporters would come up and pack the stands leaving no doubt who they were rooting for.

Many of the stadiums of my era were still being used primarily for baseball. They weren't the state of the art football facilities that are found throughout the league today. Thinking back, I'd guess that 90% of the stadiums where professional football teams played then weren't designed specifically for that sport. Places like Wrigley Field, , Baltimore, Milwaukee, Detroit. All constructed for baseball.

Football wasn't a primary source of revenue which was apparent in the way the venues were built. Close walls, a short warning track, fans right there. It could be hard on a player. But Wrigley Field had its own magic. Anybody who has played there or even seen a football game there will tell you that.

Facilities for players throughout the league in the early 1960s tended to be spartan at best. Locker rooms held the necessities for getting ready for the games, and that was about it. And the fans, they were just a few feet from the benches. You always hoped that somebody seated right behind you felt that you were playing well. There was little margin for error with the physical set up even though there were guards right there. This was particularly true in Green Bay. You never knew what might happen.

Of course all that changed when television coverage began to really take hold. Things got a lot less personalized. I believe that it was the Baltimore-New York Giants game in 1958 that marked the beginning of the big money stage for the National Football League.

After that, the dynamics were different. The fans demanded more, and justifiably so. The Bears and Packers contests began to draw a nationwide audience. Football became so popular that things changed quite rapidly throughout the league. Everybody upgraded as teams built their own stadiums. Just look at Lambeau or Soldier Field now. The older players would have been amazed.

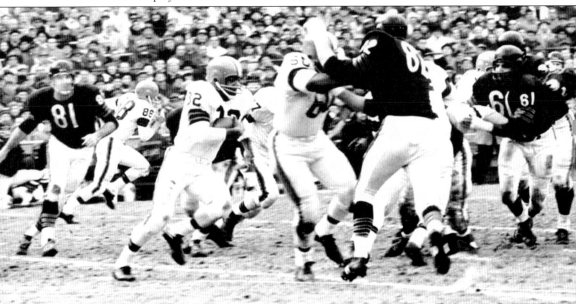

Maury Youmans (No. 82) claws his way to the ball carrier. (Courtesy of Ron Nelson at Prairie Street Art.)

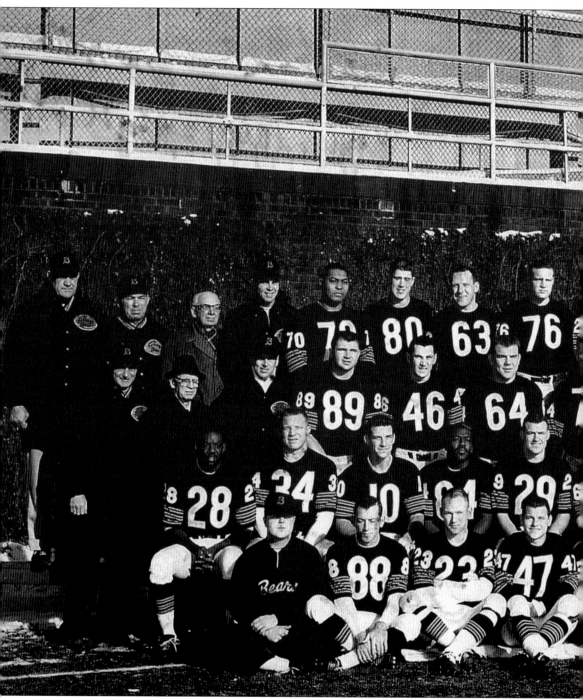

The 1963 Chicago Bears needed to defeat defending champions Green Bay during the regular

season, and they did so twice. (Courtesy of Coach Mather.)

# Rosey Taylor
1961–1969

If things had gone according to plan, legendary DB Rosey Taylor would never have been a longtime Bear. Although he was actively recruited by the team, Chicago's coaches wanted Taylor more for the people he knew than for his own strengths or skills. Taylor tells the story:

> I went to Grambling back in the late 1950s and early 1960s. This was in the days when quite frankly there weren't many African-American players anywhere in the National Football League. It wasn't an official League policy, but it was something that was understood by all of the coaches and owners at that time. It wasn't an era that the League is particularly proud of now, but that's the way things were back then.
>
> One of my friends on the Grambling team was a huge guy who went by the name of Ernie Ladd. Now Ernie was a force to be reckoned with. He weighed over 300 pounds and stood at least 6'10 1/2". Every professional team in the country knew of him. You can imagine how all eager of those pro scouts were to add him to their rosters. The competition for his services was fierce, to put it mildly.
>
> Coach Halas came up with an idea to recruit me since I was one of Ernie's closest friends. His idea was that Ladd would be much more likely to sign with a team that had his friend on the team. There were so few players from colleges down South in the NFL then that it could get sort of lonely for the players, particularly during their rookie year. If Ernie had me, the theory was, then he'd be much more comfortable.
>
> Halas went ahead and drafted Ernie, who unfortunately for George, had much more interest in joining the AFL. He tolerated Halas' overtures, but was making tentative deals with other teams at the same time. I came along as a free agent, signing with the Bears. It wasn't a great deal for me monetarily speaking. There certainly was nothing remotely like a signing bonus. I was made part of the roster for strictly minimum wage and I was grateful for the opportunity.
>
> Well, Ernie never did get to Chicago. Instead, he signed with the San Diego Chargers. Now Halas was faced with a problem. What were the Bears going to do with a DB they weren't really all that interested in? I was already in Chicago so they had to come up with a scheme to get rid of me quickly. The plan was give me no guarantees for the long term at all. If I played well, I could stay but It was made very clear that my services were required strictly on a week to week basis.
>
> What was I supposed to do? Give up and go home? That just wasn't an option. Instead, I had something to prove. But how was I going to do that when my coaches had no confidence in me? I decided to excel at everything they put before me. That way I couldn't be cut.
>
> First up, the infamous "Halas Mile," a particularly brutal part of training camp. Everybody on the team hated that drill but I saw an opportunity. I worked my tail off, running that thing twice a day every single day of the week. And soon enough, I had the record at that distance. It made headlines in the local sports pages. Guess they couldn't cut me then.
>
> Then it came time to prove myself on the field. In a game soon thereafter, I hit a #1 draft choice who went by the name of Tony Mason, so hard they had to bring an ambulance out on the field to get him to the locker room. He was out cold. The Bears couldn't cut me after that, either.
>
> Soon came the annual College All-Star-Bears scrimmage. That time, I made a mark with kick off returns. Ran them right back to the other end of the field, over and over. That bought me another 5 days on the team until they finally decided to keep me.
>
> And look what happened. The one week I was to have been with the Bears lasted

from 1961 to 1969. I was usually near the top of their interception list, and in 1963, I led the team with nine. I guess bringing me up from Grambling wasn't such a bad idea after all. The moral of the story is that persistence pays off. Which brings me to some memories of the old Bears Packers games:

When I think back to those days when we played Green Bay, the first thing that comes to my mind is pure hatred for Green Bay. Losing to those guys was simply not an option. We had to win any and every way we could. It wasn't anything personal against the players except in those particular situations. I just couldn't stand anybody from the Packers when we were on the field.

A lot of those feelings filtered down to the players from those running the team. It was clear from the first day I joined the Bears that Coach Halas couldn't stand Lombardi. There was something about Vince that drove George wild. Probably the fact that they were both such complete competitors.

I can remember the Old Man pacing up and down the sidelines before we went against Green Bay muttering to himself. You didn't want to bother the Coach when he was in one of those moods.

Halas was somewhat paranoid when it came time to play the Packers. He was sure that some way, somehow, they were stealing his game plans. In Halas' mind, it all centered on the apartments that were located near the practice field.

Halas would have his security guys out there with binoculars checking to see if anybody might be in those upstairs windows checking on what we were doing. And if he suspected something, look out. Those security men would go pounding on the doors there one by one until they found out exactly what was going on. I think they actually caught some Green Bay people that way a few times.

In 1963, one of the highlights of our championship season was beating Green Bay two times. It was wonderful. Every player on our roster played above their physical capabilities, emotions were so high. I remember a play on a kickoff where J. C. Caroline went sprinting down the field with incredible speed, pushing all of the Green Bay players out of his way. He was unstoppable, like a man possessed. And he never gave up. That's exactly what Halas expected when we faced the Packers.

The buildup to the games began days, and often weeks, in advance. Halas would bring out special plays that we'd practice only for use against Green Bay. It worked, so I had no argument with that approach. George Allen always used his best schemes when we played the Packers. It was a showcase for him to display just how good his boys could be. All the coaches were like that. Everything went up a notch during those particular times of the season.

There was no fraternization before Green Bay games, either here or up in Wisconsin. That would have sent coach Halas into an early grave. You were forbidden even to say hello to anyone who was in any way associated with the Packers. If you broke the rules, you'd be faced with a chewing out from the Coach and a heavy fine.

Actually, I did have a friend on the Green Bay team by the name of Willie Davis. We'd known each other for years and having a common background, got to be pretty close. But when we were playing each other, it was as if we had never even met. I would never bother to look at him, much less say hello. We were bitter enemies for that short period of time. Then when the games were over, we went back to being friends once more.

I think that the rivalry continues to this day on the same kind of intense level, or at least I hope it does. The Bears-Packers rivalry is so much a part of Chicago and National Football league history. We were taught this from the first days we came to the field as rookies. Packers are not your friends when you go against them on the field, and the best kind of satisfaction is when you hand them their heads on a platter. That's what Bears football is all about.

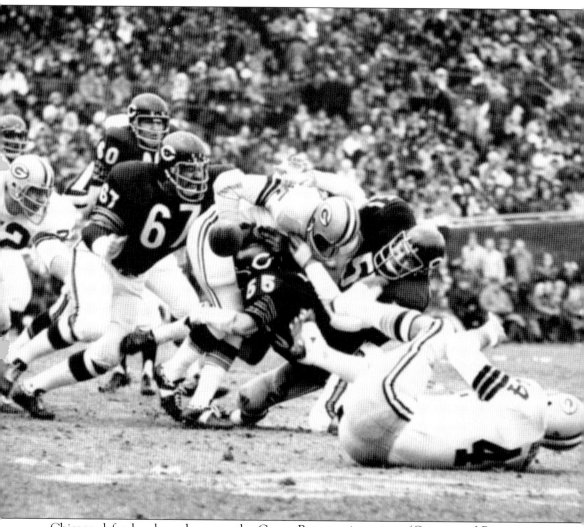

Chicago defenders bear down on the Green Bay running game. (Courtesy of Ron Nelson at Prairie Street Art.)

# Ronnie Bull
1962–1970

During his playing days, Ronnie Bull was known throughout the National Football League as an intelligent, no nonsense competitor. A specialist in the short run, Bull used his formidable leg strength and blinding bursts of speed to confound defenders.

Bull first came to the Bears' attention while on Baylor's varsity squad. His potential was viewed primarily as a threat for the defensive side of the ball, rather than as an offensive weapon. But unanticipated injuries to Bears' stalwarts Willie Galimore and Charles Bivins soon changed Bull's role with the team.

"I was so happy to have been signed, that I would have played just about anywhere they asked me to," said Bull, who went as the Bears top pick in the first round of the 1961 draft. "I was very lucky in the fact that at that time, Chicago had a number of veteran players on the roster. It wasn't uncommon for a player to stay with a team for eight or nine years. As long as injury wasn't a serious issue, they just seemed to go on and on. As a rookie, you would reap the benefit of that experience handed down."

Bull soon felt comfortable in his new position and racked up 363 yards rushing in 133 attempts and totaled 331 receiving yards in 31 attempts. He finished the 1962 season by being selected NFL Rookie of the Year. "What a thrill that was," Bull said. "Although I certainly planned to do well at the professional level that exceeded any expectation I had at the time."

During the championship season of 1963, coach Luke Johnsos informed the offense that the team's drive to domination would hinge primarily on the skills of the Bears' defense. The offense would function conservatively, in a supporting, rather than in a leading role. Despite that instruction, Bull forged on, reaching 404 rushing yards in 117 attempts for the season and getting 19 catches for 132 yards. It was an impressive average of 3.5 on the ground and 6.9 through the air. "I think that was part of the overall momentum the entire team had that year," Bull said.

Bull continued to post strong numbers through 1970, his last year with Chicago. Bull then signed with Philadelphia where he completed his career at the conclusion of the 1971 season. Looking back on Bears-Packers games, Bull's first memory is that of a rather rude introduction to the harsh reality of life in the NFL:

*I'd just been switched to the offense and I was eager to prove myself. But wouldn't you know it, my first regular season game was against Green Bay. That's when I got my "welcome to the NFL moment."*

*My first move was to do an end run. I was going pretty well until suddenly a massive figure loomed right in front of me. Bam! I felt like I'd been hit by a truck. I went down incredibly hard. I looked up and there was the Packers legend Ray Nitscke looming over me. He was just looking down and laughing.*

*On one of the next plays I went out on my route and I was hit again, this time by their RE. I don't remember his name but I definitely recall what it was like when he got to me. I had my foot planted and there was a lot of forward momentum going. So not only did I have his force to contend with, but my own as well. It was absolutely brutal.*

*What else happened that day? Oh yes, the clothesline plays. They seemed to materialize out of nowhere. One defender after another would come in and get me from behind. It happened time after time. That was really brutal. It knocked me right off my feet and I'd be kind of disoriented.*

*After a play like that, I would feel the aftereffects for quite a while. It was so different from the way they play the game now. Moves like that would never be condoned today. That would be a 15 yard penalty for sure. But back then, it was a matter of course, particularly in Bears-Packers games.*

*After the game, I asked Luke Johnsos what I'd done wrong to have sustained such hits. He said "Oh sorry kid. Forgot to tell you about going wide and getting out of the*

way of those guys." "Thanks coach. That advice is about a day late and a dollar short," I replied.

But what I learned from that first encounter with the Packers altered my route on the field considerably. Rather than cut down to take the up field fast, I'd start a sweep to the outside. It might have been somewhat slower, but it seemed safer. I'd do just about anything to stay out of Nitschke's way.

Years later long after we were both retired, I happened to run into Nitschke at a charity function. I'd been friends over the years with many former Packer players and I was glad to see Ray. I went up and said hello, waiting for a greeting back. I was more than a little bit startled when Nitschke let out a tremendous growl in return. Had I done something to offend him? I was trying to understand the situation.

I asked Fuzzy Thurston who was there and was known as a pal of Ray's why on earth Nitschke would still dislike me. After all, we hadn't played against each other in years. "Oh no, kid," he replied. "There's no problem. In fact, Ray thinks the world of you. If he growls, he likes you. It's when he's not growling that you need to watch out."

I'm always somewhat surprised when, during the course of casual conversation, people bring back details to me of those long ago Bears Packers games. But that's just a measure of how important they were to the city of Chicago. My theory is that this originated with Halas who made no secret of the fact that life was perfect any time we could beat Green Bay.

This was particularly true during our championship season of 1963. The Packers were such a dominant team then. Halas just couldn't stand the prospect of Lombardi's coming away with that trophy one more time.

Halas formulated a plan. He went to his coaches and they installed a series of schemes just for use against Green Bay. We worked on that all that season. Say we were meeting San Francisco on an upcoming Sunday. Well, we'd practice for them most days of the week but one day always was set aside just to work for the eventual meeting with Green Bay.

Halas would concentrate on what he thought would be high percentage plays. Wade preferred the deep down field ball, say a 60 yarder. He'd almost get it there, but then the pass would drop short of the receiver. "We're not using that" Halas would say "That's only a 10% play." Then Wade would try a 40 yard pass. When that fell short as well, Halas said "No, not that one either. That's a 20% chance. This season, it's all going to be one hundred percent." Coach and Wade got into some big arguments over that.'

On and on, week after week the game plans progressed. Eventually, Halas got what he was after. We had the two wins over the Packers, then went on from there. We all still wear the rings to prove the wisdom of Halas' approach so I'm certainly not going to argue with that kind of success.

My only regret about the present day Green Bay-Bears rivalry is that I think the intensity has lessened somewhat. When I played, it was a tradition that was passed down from one player to another. Almost as soon as you'd join the team, one of the veterans would take you aside and tell you about the importance of these games. It was vital that rookies understand.

Now the composition of the teams changes frequently. Players come in and then they leave. Tradition and team history tends to get lost in the mix. But this rivalry deserves respect. It's one of the first and definitely the best in all of professional football.

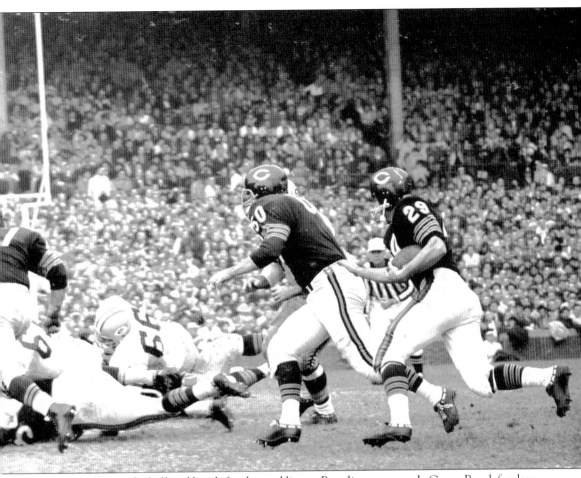

Ronnie Bull grips the ball and heads for the goal line as Bear linemen topple Green Bay defenders. (Courtesy of Ron Nelson at Prairie Street Art.)

# Jim Dooley
Player 1952–1954, 1956–1957, 1959–1962
Coach 1968–1971

As the appointed successor to head coach George Halas in 1968, Jim Dooley took over for the NFL icon "ready to do his best for the team and for Chicago." His elevation to the team's top position was somewhat of a surprise to Bill Wade who felt at that time he himself was on the fast track to take over.

Although Dooley certainly wasn't a stranger to Bears football, having been a wide receiver for the team from 1952 to 1961, still many in town agreed with Wade who claimed Dooley to be "a strong and dependable player in his day and fine assistant coach material, but certainly not capable of directing the entire team."

A well known receiver in college, Dooley first came to the Bears from Miami as the top pick of the 1952 draft. Dooley looked forward to joining what he later characterized as "one of the most exciting teams in the NFL at that time."

His career totals in Chicago were solid, with 211 receptions for 3,172 yards. Any criticism he might eventually have received would come during his coaching tenure, which ended at the conclusion of the 1971 season. Dooley's greatest regret from his coaching days?

> Losing Louisiana Tech QB Terry Bradshaw to the Steelers as the result of the toss of a coin. We were tied with the Steelers with records of 1-13. It was all decided by the league on this one flip of the coin. It was devastating for Chicago. Pittsburgh ended up with Bradshaw who eventually took them to four Super Bowls. I guess that luck just wasn't on our side that day.

Dooley instead had backup quarterback Bobby Douglass to work with, a match certainly rivaling any Odd Couple tales.

> We roomed together for a week. It was just crazy. Bobby would sneak out of our place at all hours heading to the bars on Rush Street. I'd have to go out there after him at all hours of the night. What I was trying to accomplish during that time was to drill some of our plays into his head. He was a free spirit and wanted to do things his way. Bobby was and is a very intelligent man. That wasn't the problem. He just didn't like to be told what to do.

Both as a coach and as a player, Dooley viewed Packers games as must win situations. Just as his mentor had taught him, Dooley was willing to do whatever it took to get a victory:

> As soon as I took over the Bears, that became my number one priority. "Do what you have to do, just get the Packers." Halas said that all the time. The first time we met them in Green Bay in 1968, the Bears came out on top 13-10. What a great day that was for all of us. I felt that to be somewhat of a vindication personally and for the team as well. The second game that year was at home. We lost a heartbreaker 27-28.
>
> 1969 didn't go too well with two losses to the Packers but we got one win off of them in Green Bay by a good score, 35-17. In 1970 we had one loss and one win and in 1971 I'm sorry to say we didn't come out on top either time.
>
> Halas always worked up a scheme specifically geared to the Packers. I did that as well. You always wanted to surprise them with something a little different, as well as using what you were pretty sure would work against them.
>
> What used to make the Bears absolutely furious was when Lombardi would stand there on the other side of the field just grinning away. It was more of a

grimace actually, but to those on our bench, it always looked as if he were making fun of us. No matter what happened, he'd stand there cool as can be, smiling.

One time we were ahead during all of the game and Lombardi didn't seem at all ruffled. He looked as if he had a plan in mind and unfortunately, that proved to be the case. The Packers got the ball back and kicked a last minute field goal for the win. I heard coach Halas screaming on the sidelines "What in the heck do I have to do to beat that SOB?"

Lombardi was such an incredibly mean fellow, at least to his players. One of them, Jim Ringo, was Packer captain. He eventually came to the Bears as a coach. Jim told me once that all of the Packers were terrified to bring any grievance to Lombardi. This went on no matter how long they'd been with the team. So the job fell to Jim. Players would come to him day and night with one grievance or another, then Ringo would relay the messages to Lombardi. It didn't make him the most popular person with his coach.

I always viewed Lombardi and Tom Landry as two of the most brilliant minds in football. They were specialists who saw things the rest of us couldn't fathom. Their knowledge of the game far transcended any fundamentals that the rest of us might have learned along the way. That their two teams became so successful was never a surprise to me. These men were ahead of the league in so many things that they did. They just understood the game inside and out and knew how to turn things that happened on the field to their advantage.

In the 1940s, Halas' T formation was the play every team wanted to copy. It was that way through most of the games between the Packers and the Bears. Other organizations would watch what we did as far as preparation and execution. Then they'd translate the aspects that would be helpful for them. We'd run something unique and sure enough, you'd see it in three or four other teams within the week.

I think that on many levels, Lombardi and Halas appreciated each other. They might never have admitted that publicly, but I'm convinced to this day that was the case. These were some of the most original men in sports. They were the beginning of so much of what we see in football today. You have to respect that fact.

Whenever I'd go against the Packers as a player, I knew I'd be in for trouble. It seemed as if they always got their biggest and meanest defender right there on my tail. Halas used to name some plays after members of the team if they executed the moves particularly well. I had a few-the Dooley In, the Dooley Out, things like that. I was always very proud of that fact. But the Packers were sure to let me know if I didn't successfully execute a play that had my name on it.

Looking back, though, it was all great. There was a rivalry, definitely, but underneath it we were friends in a way. We'd all shared that unique experience together. The object was to play as hard as you could and make as few mistakes as possible in those games. Whoever succeeded, won. It was just that simple.

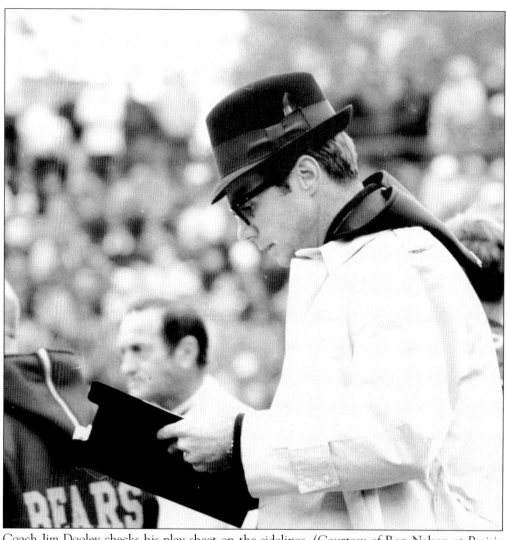

Coach Jim Dooley checks his play sheet on the sidelines. (Courtesy of Ron Nelson at Prairie Street Art.)

Bear great Gale Sayers watches from the sidelines at a frozen Wrigley Field. (Courtesy of Ron Nelson at Prairie Street Art.)

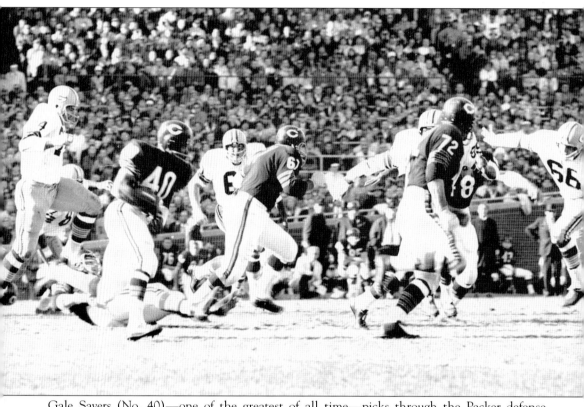

Gale Sayers (No. 40)—one of the greatest of all time—picks through the Packer defense. (Courtesy of Ron Nelson at Prairie Street Art.)

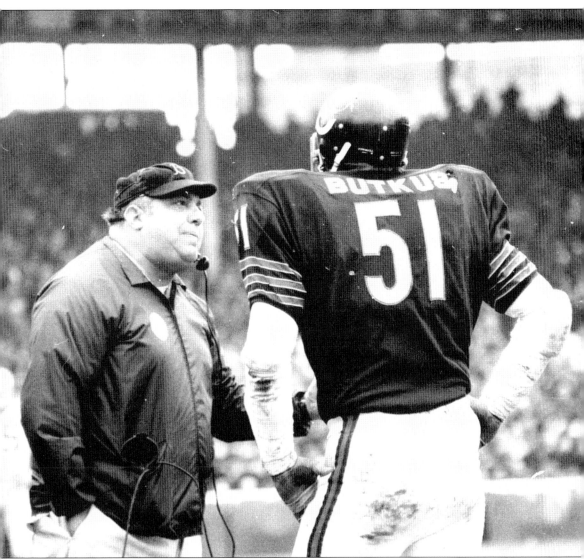

Coach Abe Gibron consults with legendary Bears linebacker Dick Butkus on the sidelines. (Courtesy of Ron Nelson at Prairie Street Art.)

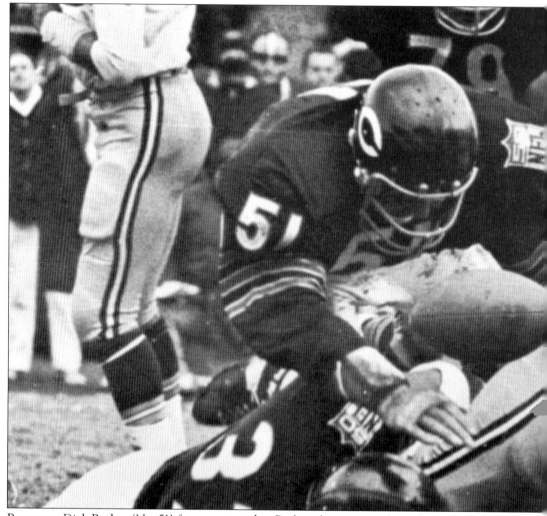

Bear great Dick Butkus (No. 51) forces yet another Packer player to cough up the football, 1971.

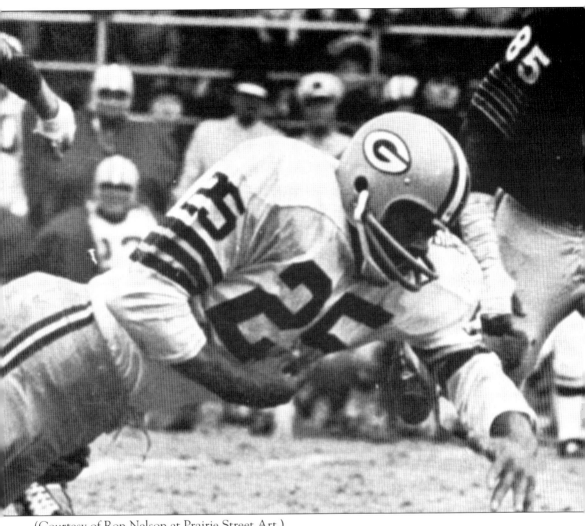

(Courtesy of Ron Nelson at Prairie Street Art.)

Dick Butkus (No. 51) rallies his fellow Bear defenders at the line of scrimmage. (Courtesy of Ron Nelson at Prairie Street Art.)

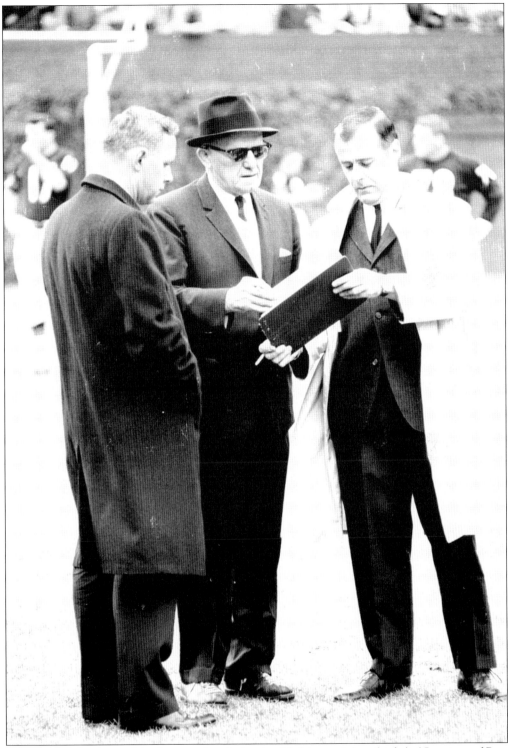

George S. Halas (center) looks over the playbook with his son, Mugs (right). (Courtesy of Ron Nelson at Prairie Street Art.)

# Doug Plank
1975–1982

When former Bears safety Doug Plank was on the field, every member of the opposing offense made it a point to find out exactly where he was—at all times. Not to have done so often brought disastrous results.

"I remember one game against the Broncos," Plank recalls. "It was a Monday Night event and we all were playing pretty hard because it was on national television. I'd been clipped earlier in the game and I was real steamed up about it. Paul Howard had a sweep play that happened to come in my direction. I don't think he saw me standing there waiting for him to make his move. I went after him and ended up hitting him so hard that my helmet wedged itself way down into my shoulder pads. I had to put my fingers into my helmet's ear holes just to get my headgear off. The rest of their receivers stayed away from me the rest of the night."

Always known as a hard hitter and a fierce competitor, Plank's accomplishments on the field were so impressive that defensive coordinator Buddy Ryan named the famed 46 Defense after Plank's number.

> *That was a common practice in those days. Certain schemes were associated with players' names or numbers. Usually the shelf life was a week or two. For some reason, mine's still used. I was always a little annoyed about it though, because Buddy used my number and not my name.*

Plank joined the Bears in 1975 and soon became an indispensable part of a team known for its formidable defense. His durability and his competitive spirit made him the bane of opposing teams and fan favorite in Chicago. After playing for the Bears for eight years, he was reluctant to even consider retirement. But Plank's numerous seasons in football eventually extracted a physical toll and made him realize that it was time to leave the game at the conclusion of the 1982 season.

> *I played football for years, from grade school through high school, then as a starter at Ohio State, and finally with the Bears. Protective gear wasn't nearly as advanced then as it is today. In all, I had 30 concussions, a spinal injury, and some knee damage. It just got to the point where I wasn't able to continue.*

After leaving football, Plank entered a number of business ventures including commercial real estate, broadcasting, and the fast food industry. He also served as the Arena Football League's Arizona Rattlers defensive coordinator. Today he is head coach of the Georgia Force, also in the Arena League. Plank also remembers some times in Green Bay when things were pretty intense:

> *I didn't really appreciate the Bears-Packers rivalry until I actually got to Chicago as a member of the team. Before that, about all I could equate it to was the traditional Ohio State-Michigan contests. There was always a lot of bad blood there. But the Bears-Packers games were always at an entirely different level. It was unbelievable just how rough things could get.*
>
> *Pressure to win came from every source before those games. I could hardly go out for the newspaper in the morning without somebody mentioning Green Bay. Even my neighbors would get on me, telling me that we had to win. I'm an emotional guy and I was so worked up before the first game I played in Wisconsin it was unbelievable. I really didn't know what to expect when the team arrived in town. I was certain that bad things would happen. From what I heard, rioting in the streets wouldn't have been too much of a surprise.*
>
> *I could tell just how nervous I'd become by the dumb mistakes I'd make in some of those meetings. During that first away game in Green Bay as a rookie, I made*

two unnecessary roughness plays that the refs caught. That was 30 negative yards in a row, all due to me.

As I walked over to our bench, I saw one of the refs standing there talking to coach Pardee. He said quite loudly so I'd hear "you'd better think about taking this guy Plank out right now. He's losing the game for you." I was absolutely mortified. We ended up losing to Green Bay 7-28.

The next day back in Chicago, we had to look at the game films. For me, it was like reliving a nightmare. I had no idea what I'd been doing out there. I saw myself going through the plays as if I had been sleepwalking. It was almost an out of body experience, something I hope that I never have to experience again.

It was amazing that the coaches weren't harder on me then they were. Luckily, they didn't trade me right then and there. Instead, they gave me time to mature and learn how to keep my head in the game. Otherwise, it would have been all over.

The week leading up to a game against Green Bay was always a unique experience. Preparation was much more intense than for an ordinary season game. But I always felt that the will to win was so strong in all of the players that this extra motivation by the coaching staff wasn't really necessary. If anything, there was the chance that it could backfire and produce results like I had that first year.

I always minded my manners when we were the visiting team in Green Bay. That was for several reasons. One was that since most of us played with the Bears for quite a few years, it was impossible to be anonymous. The fans in Wisconsin knew us pretty well, both by name and by number. They'd keep an eye on us and if they were mad, look out.

I didn't really mind the taunting. That's part of any rivalry, but what bothered me was the fact that quite a few residents of Wisconsin are hunters. Therefore, more likely than not, they'd be toting guns. Or that was my point of view at the time. I made sure never to have any verbal or physical contact with any of them. And I definitely never looked them in the eye.

Years after I retired, I'd have the occasion every now and then to run into these same Green Bay fans at one signing event or another. I knew who they were as they'd always bring one of my old cards up to me and say something like "well, we hated you at the time but now we respect your playing ability." That was fine with me. I was more than happy to let bygones be bygones and give them the autograph.

I also became casual friends with some of the Green Bay players quite a bit after I'd retired. James Lofton and Lynn Dickie were good guys. We got along fine, just not when facing each other on the field.

Now things have changed in that traditional rivalry. I think back to the 1970s, the 1980s and I remember how much we loved to hate Green Bay. I made our season if we could beat them. But increased player mobility has altered loyalties and downplayed emotions.

I think a Green Bay fan said it best a few months ago: "You know we couldn't stand any of the Bears when the Packers played against you. But now somebody is with the Bears one season, then joins Green Bay a year later."

That takes a lot of the fun out of things. It's hard to get very worked up when players are going back and forth across the state lines all the time. I really miss those hard hitting days when we'd do just about anything to get those dirty Packers.

# Dan Jiggetts
1976–1982

Dan Jiggetts was the prototypical Bear for his day. A formidable lineman who was able to combine a keen intelligence with an equally strong competitive instinct, Jiggetts made his mark on the team during his playing years in Chicago from 1976 to 1982.

Jiggetts came to the Bears from Harvard University where he was team captain during his senior year and a key ingredient in that team's first Ivy League Championship. He was an All-American senior year while earning a degree in government and economics. As a rookie OT for the Bears, Jiggetts joined one of the most notable lineups in history which included standouts such as Walter Payton, who would become a close friend and mentor.

"Walter was a unique personality," Jiggetts recently recalled. "And I feel blessed to have known him. What I remember best was his off the field practical jokes. He'd have something new every day. We were always on alert because we'd never know for sure what he'd try next."

Jiggetts also felt fortunate to have the opportunity to observe Payton in game day situations.

> On the field, he was magnificent. He was the best at his position ever. He'd find holes when the rest of us were certain he'd never get through. And his athletic ability? Outstanding. He could cut then run with blinding speed. He had surprising strength in his arms and legs. That was the result of his constant intense workouts. He'd push those defenders right off.
>
> But in retrospect, much of his success came from his overall attitude. I've never encountered anybody with such a strong will to win. He just never gave up. I think that quality came forward once more when he was battling his illness. Walter was an optimist who never surrendered. That's why it was such a shock to all of us when he passed away.

As a player, Jiggetts savored the opportunity to be coached by George Halas.

> One of the more exciting aspects for me in joining the Bears was the opportunity to play for coach Halas. To anyone growing up in a football environment, he was a legend. I'd heard stories about him all of my life, most of which turned out to be true.

For example?

> Well, he was tight with a dollar and he kept an eagle eye on every aspect of the team. None of us could get away with anything. But he also had a less apparent softer side. Coach Halas looked out for the welfare of his players, both when we were with the team and after we retired. He wanted to be certain that we knew what we'd be doing after football. Halas wanted us to be successful in life, not just on the gridiron. The Bears were an extended family in that sense, all looking out for each other. Those seven years with Chicago constituted a period of my life that I'll never forget.

Jiggetts's time with the Bears was a period when the team often dominated the Packers, something the retired player remembers with a great degree of satisfaction.

> We went up to Green Bay expecting to win and more often than not, that turned out to be exactly what happened. I think an attitude like that is self fulfilling. Success breeds success. I don't remember ever being intimidated by the prospect of facing Green Bay. Instead, it was a game I always looked forward to.

Currently, Jiggetts observes the games from a different perspective as an integral part of television's Comcast Sportsnet team. Since leaving professional football, he's also hosted his own radio talk show and has been a featured contributor for pre and post game television broadcasts for Fox Television. Jiggetts remembers his early days with Chicago and that first trip up to Green Bay:

> It was mid November, I believe, and it was incredibly cold for that time of year. I'd heard stories about how bad it could get but this particular day exceeded all of my expectations. It was so brutal that I've always thought of that as my "welcome to the NFL and to the Green Bay-Bears rivalry" moment. We won 16-10 but my body was so frozen that I almost didn't care.
>
> At least we had heaters on the sidelines. That was a better situation that the one they had when we played in Minnesota. It was very odd as Bud Grant didn't allow any heaters at all on the field, so his guys froze too. And I never understood why all of the players from both teams were on the same sideline. It was strange, and very cold up there.
>
> But back to playing the Packers. Noah Jackson and Revie Sorey told me how to get the best chance at staying somewhat warm. They said to coat my feet with Vaseline then put them in plastic bags. Then I was to put on my socks and shoes. I'm not sure how much this helped, but I guess it offered some relief.
>
> My favorite game against the Packers was the one that we won 61-7. That was a home game in early December, 1980. I think that some of the Packers were pretty bitter after the game was over because they felt that we'd tried to run up the score. Guess what? They were right. Once we hit the 40 point mark, coach Neil Armstrong took us aside and suggested that it might be best not to let the score get to more than 50 points for our side. "Just run the ball and run out the clock" Armstrong said.
>
> That didn't go over at all well with the team. After all, we were playing the Packers. We all knew that if they had the chance, they certainly would have run up the score on us. Mike Phipps, our QB, said "The heck with that" and proceeded to keep throwing the ball deep. Armstrong wasn't amused but we all encouraged Mike to keep going just like that. One bomb after another went sailing down the field. What a wonderful sight. I think that one play alone netted us 40 or more yards. It was a magnificent afternoon.
>
> I've been asked whether I came into the National Football League knowing about the rivalry or whether it was something I learned about once I was there. I guess the answer is that it was a little bit of both. I think that anybody who followed football at that time certainly knew that Green Bay and the Bears had something going on between them, after all that was an integral part of football history. But I never realized the intensity of the rivalry until I was in a Bears uniform myself.
>
> The whole atmosphere surrounding those games was so much more than you ever encountered during a normal game. There was a huge game week buildup by the coaches. The players would really get into the spirit of things. By game time, we were ready to get brutal.
>
> As a rookie, I was told what to expect by the veteran players, yet what happened out on the field was far beyond what I ever anticipated. Its something that you have to experience personally to fully understand. Then as a second year player, I passed what I had learned from these games on to the next generation of new Bears. That's the way the rivalry worked.
>
> This went on for years and still continues today. It's what I like best about this tradition. Bears-Green Bay games are an integral part of each team. Every one of the players recognizes that, whether they are in the lineup for a year or for ten years. You can't fully understand the history and tradition of either team until you've participated in, or at least seen, one of these games.

Green Bay defenders often ended up with head-in-hands after an afternoon trying to stop Walter Payton. (Courtesy of Ron Nelson at Prairie Street Art.)

# Brian Baschnagel
1976–1984

Brian Baschnagel's introduction to big time football came while he was still a high school student, on the day that legendary Ohio State coach Woody Hayes came by for a recruiting visit.

"I wasn't sure exactly what to expect," Baschnagel said recently. "Everybody in town knew who Woody Hayes was and they were aware that he was dropping by our house. It was pretty intimidating."

What surprised Baschnagel even more than the coach's personal appearance at his front door was the fact that Hayes never spoke about his football program.

> *Looking back, it's clear to me that Coach Hayes was a teacher first and a coach second. He asked me all about my academic goals in college, what my major might be, and what type of a career I was thinking of going into after graduation. That seemed a long way off at the time. I was more interested in hearing about the athletic facilities and about football in general. That's what I'd talked about during the other schools' recruiting visits.*

But Hayes' unique approach worked on the young wide receiver. Baschnagel went to Ohio State and soon became a star, going to the Rose Bowl with his team four times in four years and receiving Academic All-American honors. At the beginning of senior year, Baschnagel began to think about turning pro.

"I went to Hayes' office to discuss things. The Coach wasn't at all amused," Baschnagel recalled. "I had told him years before that I was quite interested in both business and the law. I think he assumed I'd go right from undergrad to graduate school. He didn't want to talk about my going into professional football."

Baschnagel didn't see much of his coach from the time the Ohio State football season was over until he was drafted by the Bears. "When I stopped by his office to break the good news, his reaction was quite pronounced, but not in the way I expected. Coach said that I was throwing away my chance at a productive future and that he didn't want to see me again until I was in graduate school."

Although he didn't follow Hayes' wishes, Baschnagel ended up as a success both on and off the field. As a Bear from 1976 to 1984, Baschnagel was a dominant force, setting a number of team records, including 104 receiving yards against the Vikings in October of 1979, and 1,766 total kickoff return yards from 1976 to 1978.

When his football career was over, Baschnagel became a salesman for a Chicago area distributor of packaging materials, graphics, and industrial supplies. He also served as an NFL on-field representative during home games, checking on uniform violations and reporting any infractions to the League head office. But that still wasn't enough, still didn't please Coach Hayes.

"I even enrolled in an off season academic program back at Ohio State while I was still with the Bears as a way to continue my education," Baschnagel said. "I stopped by to tell Coach Hayes and he still wasn't happy with me. All he could say was 'tell me when you've finished law school.' I guess there was no way I could please him unless I ended up as an attorney. Coach Hayes took academics very seriously."

Looking back, Baschnagel feels fortunate to have accomplished so much both in football and in the world of business. He's delighted to have retired from professional sports relatively injury free despite years of hard hits by various defenders, some of the most brutal having been delivered by players for Green Bay:

> *Those games were tough and physical, there was no doubt about that. There was a heightened state of awareness that most of us felt whenever we went against the Packers. As a rookie coming in, this was something that I learned almost immediately. In my mind, I likened it to some of the Big Ten rivalries that were familiar to me as*

college player. After the first defender tackled me, however, I realized these games were football on an extremely intensified physical and psychological level.

My surprise at what I experienced on the field wasn't due to a lack of preparation. The veterans had tried to explain things to me from the time I initially unpacked my bags in Chicago. The Packers were often a subject of conversation.

One of the first times I was in the Bears locker room, Doug Buffone took me aside to tell me about Green Bay games. I guess he felt that it was his job to set me straight about the importance of the rivalry. I learned from listening to him that day just how much beating the Packers meant to every member of the Bears organization. It definitely was not a game to be taken for granted.

During the Mike Ditka-Forrest Gregg years, the emotions ran even higher, which is hard to believe as feelings were pretty tense even before that period of time. Ditka never ever wanted to lose to anybody. Mike's experiences from his days as a player made him just that more intense. He took the rivalry very personally and expected his team to do the same. In his mind, the harder we played against Green Bay the better.

I think the fans felt the same way about things when these two teams faced each other. Tickets always sold out for these games very quickly. The stadiums would be packed with the home town faithful and as many of the "enemy" as were able to get seats. Everybody would be cheering and generally carrying on.

One of my most vivid memories of Packers fans is the first game in Green Bay that I played in as a rookie. As was often the case when we traveled up there, it was bitterly cold. We were jumping up and down on the sidelines just trying to keep warm.

Late in the game, Chicago was ahead by three or four touchdowns. There was no way the Packers were going to come back on us that day. But not one person left the stadium. It was a sea of green and gold even towards the end of the fourth quarter.

Looking around Lambeau when I was off the field, I couldn't see any empty seats although the weather conditions were miserable. That said a lot to me about the loyalty of the Green Bay fans. They always held on to the hope that no matter how bad things might seem during a game, their team would inevitably come back and beat the Bears.

Green Bay people were surprisingly polite when we went up to the games. I was amazed at the time as I'd been expecting some degree of hostility from them. There was never anything but complete respect. I didn't even hear any of the noise that was supposed to have kept Bears players from getting a good nights' sleep before a game. From the tales that had been told, I'd been expecting just about anything and was amazed that things seemed so peaceful. But maybe I was just a sound sleeper.

Steve Luke was a friend of mine from college. We played ball together at Ohio State when he was a center when I lined up as a receiver. When he joined the Packers as a strong safety, I looked forward to the games as a time to renew our friendship. I hadn't seen him in a while and wanted to catch up on old times.

The first year we were both playing, I went up to him during warmups and said something about the infamous Green Bay "Swat Team" which was a nickname for their defense. Evidently Steve was offended by what I'd said because he muttered something about "media hype" and "dirty Bears" then turned and left without another word. I learned then that you never talk to a Packer before a game, even if you played next to him in college. It's just not the appropriate time to be friends so I left him alone after that.

I hope that the rivalry continues with those heightened feelings on both sides. That's the enjoyable part of the whole thing. It's not just another game. Green Bay and Chicago coming together is always a special occasion.

*I think that Bears and Packers players and fans are always going to feel that these games are important. When I'm down on the field now before the games in my NFL capacity, I still notice the tension on both sidelines and in the stands. There's an overwhelming sense of excitement. That's undoubtedly why Green Bay was selected to play the first game at the dedication of the new Soldier Field.*

*These are the games that diehards look forward to all year. It's been kind of one sided recently, but I think the Bears can come back and even things out eventually. There's too much history and tradition to just let this thing go.*

# Jerry Vainisi
1972–1986

Former Bears' GM Jerry Vainisi had strong ties with both the Bears and the Packers due to a long-standing family relationship with one team, and employment by the other.

Vainisi always knew that he wanted to be part of professional sports. Seeing his possible entree coming through the front office rather than on the playing field, Vainisi developed skills in accounting and law that would become pivotal in the new age of contract negotiation within the league.

But Vainisi's experiences would become more personal than that of most new hires. He grew up in a household devoted to the Packers, where his brother Jack was employed. Hoping to follow Jack into the league, Vainisi's first job interview was with Vince Lombardi, whom Jack had recruited for Green Bay.

Although he didn't get the job, he did receive the opportunity to have his resume distributed to Lombardi's friends, a move that eventually led to Vainisi's association with the Bears. Vainisi risked everything, including a sizable cut in pay, in his search for a position he knew he had the qualifications to fill. A combination of luck and word of mouth led him to his hometown team and provided benefits Vainisi had neither sought nor anticipated.

"I acquired a whole new family," Vainisi said recently. "During my years with the Bears, I became what I viewed as a surrogate son to George Halas, Sr. and a surrogate brother to Halas' only son, Mugs. These were meaningful relationships that went far beyond the day to day operation of a professional football team."

Vainisi was instrumental in the building of the Bears' 1985 Super Bowl team and was part of the inner sanctum during Coach Halas's last years as well as during the Ditka era. Vainisi remembers how it all began:

> My ties to the Bears go back a generation to the early 1930s and 1940s, when the players used to frequent the delicatessen that my father and uncle owned on Wilson Avenue in Chicago. The grocery was directly across the street from the Sheraton Plaza Hotel where many of the Bears stayed during the season. They'd drop in at all hours to say hello and to grab a bite to eat.
>
> Gene Ronzani, who was very close to Coach Halas, came by all the time. He informally coached my brother Jack, who was 14 years older than I was, when Jack played right tackle at St. George's High School in Evanston. Ronzani and the Bears players would come to St. George's on Saturday afternoons and watch his games. Then Jack would return the favor by attending Bears games on Sundays.
>
> Jack got a football scholarship to Notre Dame where he was a standout player. He was drafted into the military after freshman year and went to Japan where he came down with rheumatic fever. Jack was severely ill and ended up in a hospital for a year. Once he was discharged, he no longer could play football, but he did go back to Notre Dame, graduating in 1950.
>
> About that same time, the Packers hired Ronzani to replace Curly Lambeau. Gene called Jack asking if he might have interest in joining the Green Bay staff to oversee personnel. Jack jumped at the opportunity and soon established a network of college scouts for Green Bay. I think they were paid only twenty-five dollars a game, but it was a good way to get started in the league. One of the scouts Jack relied on most was Jim Finks who would later become Bears GM.
>
> Jack had a wonderful ten year tenure in Green Bay, outlasting four full scale personnel purges. His decisions as far as drafting top players had a very positive impact on the Packers for many years. There was no doubt that he was one of the best at his job in all of professional football.
>
> Who did Jack and his scouts discover? Paul Hornung, Ron Kramer, Ray Nitschke, Bart Starr, and Jerry Kramer, among others. He also was instrumental in securing Vince

Lombardi as Packers coach. What I liked best about his job, though, was that I had the opportunity to be the Packers ball boy in '57, '58, and '59, along with Lombardi's son, Vince Jr. For a kid who loves sports, it doesn't get better than that.

Having a brother with an exciting team like Green Bay was a real experience. I became a Packer fan through and through. I even had a dog I named Packer at one time. Clearly, I never imagined that I would end up working for the Bears organization.

My opportunity came in 1972. I was a young accountant who had been working at Arthur Anderson in Chicago since graduation from college. My undergraduate degree from Georgetown was in accounting. It seemed to be a good all purpose thing to know before entering the business world. And coincidentally, Georgetown was where I became friends with Paul Tagliabue, who in later years became the commissioner of the NFL.

After college, I got married and soon had both a wife and small children. I was really struggling to make ends meet. I started classes at Kent College of Law at night hoping that would lead to a more lucrative career. In 1968, a year before I would graduate, I called Coach Lombardi asking for an interview. I'd come up with the theory that players contracts should be negotiated by lawyers, not by former players who might not be that familiar with the law as it relates to athletes. I just wanted a few minutes with Lombardi to run some ideas past him.

He ended up giving me two hours of his time. As the meeting was winding down, I asked the Coach if he might consider me for a legal position within the Packers organization. Lombardi laughed and said "Kid, if any of my former ball boys are going to work for me at the Packers, it will be my son, Vince Jr. He went to law school too you know." He did ask for my resume, though, and said he'd send it around the league for me.

I did get two calls as a result of that meeting. The first was from Lamar Hunt who was then the AFC President. The other came from George Halas who was then president of the NFC. I soon realized that I wasn't quite ready for that level of employment. A position as the league's labor affairs lawyer also opened up, but I just didn't feel I had the experience to assume those responsibilities. So although I didn't get the jobs that were open, my resume was circulated once more. I tried to be patient, feeling certain that the right thing would come along. Finally one day, I got a call.

I picked up the phone and there was a guy on the other end of the line who claimed to be George Halas, Jr., or Mugs as he was called. I was sure it was a prank. It wasn't beyond the realm of possibility that one of my friends would try something like that. Everybody knew how much I wanted a job, any job, in professional sports. I thought at first "Why would Mugs call me?" and was just about to make a smart remark then hang up when something stopped me. I simply replied "Yes?"

It was Mugs, and he asked if I'd be available for an interview with the Bears.

"When?" I asked.

"When are you free?"

I hastened to tell him that my schedule was my own and that I would be available any time at his convenience. He suggested that I might come in later that week. I immediately agreed. Then he paused and asked if I had any time later that day. My mouth went dry but I managed to whisper "Yes. Is ten minutes soon enough?"

I left the office immediately and floated all the way over to the Bears office which was a short distance from Arthur Anderson. I wanted that job so badly that my nerves were starting to kick in, but as soon as I met Mugs, I felt immediately at ease. It was as if we'd been friends all of our lives.

Shortly after Mugs and I began talking, Halas Sr. happened to drop in. I knew that this was no accident, that he wanted to take a look at me and see if I'd fit into the Bears organization. When he stepped into the room, I jumped to my feet just as I had been

taught to by my mother and my grandmother. Manners were always very important in my family.

This evidently made a favorable impression on the Coach as I got the job offer shortly thereafter. It was somewhat of a shock to me as a lifelong Packers fan to be joining the Bears but I was thrilled anyway. To be in professional football just like my brother Jack, who had died in 1960 at age 33, was something I'd always hoped for. I wanted the position so badly that I even took a drastic pay cut, going from Anderson's $24,000 to the Bears $18,000. But I didn't hesitate for a minute. I knew that this would be the opportunity of a lifetime.

My title officially was controller and in house counsel although my actual duties were quite wide ranging. I got to experience just about every aspect of life in the National Football League during an era of great change. The relationships I developed became as meaningful as the job at hand. I worked closely with Coach Halas and Mugs for the rest of their lives, eventually becoming Bears GM after Mug's untimely death.

I had the opportunity to be with the team through a time of great excitement and anticipation. There were ups and some downs of course, but it always felt as if progress toward our ultimate goal was being made. A Super Bowl was on the horizon, it was just a matter of getting the proper pieces into place. In fact, Jim Finks and I had promised as much to Coach Halas shortly before he died.

This was during a period of transition to what the league has become in modern times. Televised sports were becoming important. Football was big business and the media spotlight was on the varied personalities of the players.

You couldn't have had a greater cast of characters than the Bears teams and coaches of the 1980s. I was fortunate to have been there through the great Jim Finks drafts. I worked with Mike Ditka when he became head coach, and I watched firsthand as one of the greatest Bears teams of all time was assembled.

But best of all, I worked closely with Coach Halas from 1972 until his death. He was a crusty fascinating individual who enjoyed and expected complete control of his team. One of my favorite memories was the glasses of wine we'd share at the end of each business day. We'd sit back and he'd tell stories of players and the early days of professional football. I don't recall many specifics of these conversations. I'm just sorry that I didn't have a tape recorder at the time so I could remember all of the details.

Looking back, would I have enjoyed the chance to be in Green Bay? Probably. Lombardi was certainly a legend in his own right and I would have learned so much from him. But Jack had that opportunity and I think things turned out the way they should have. Those moments with Coach Halas and with Mugs, with Ditka and Finks were something completely unforgettable. I've never had any regrets that I was hired by the Bears.

Coach Mike Ditka paces the sidelines. (Courtesy of Steve Woltmann.)

# Bob Avellini
1975–1984

Quarterback Bob Avellini came to the Bears in 1975 during a time of turmoil and subsequent rebuilding within the organization. The early 1970s hadn't been kind to the team and it was clear that major changes had to be made. In 1974, Jim Finks, the former Minnesota Vikings general manager and vice-president, agreed to assume responsibility for the Bears' day-to-day operations at the behest of his longtime friend, Mugs Halas.

This was the first time ever that the general manager and chief operating officer's position would belong to somebody outside of the immediate Halas family, but with years of experience as a Pro Bowl quarterback for the Steelers, an assistant coach at Notre Dame, the GM for the Calgary Stampeders, then GM for the Vikings, Finks was well qualified for the job.

Fink's primary task at the time was that of revitalizing the team. Along with Noah Jackson, Roland Harper, Doug Plank, Walter Payton, and Mike Hartenstine, one of the first players he brought in was Maryland University's Bob Avellini.

Results weren't immediate and 1975 didn't turn out to be a stellar year for Chicago, with a last place 4-10 record. But Avellini had shown skill and poise whenever he was brought into a game. He was named starting quarterback in 1976 and began to make a noticeable impact. With the addition of Brian Baschnagel and Payton's increasingly impressive presence on the field, things seemed to be looking up offensively by 1977.

At the conclusion of the 9-5 1977 season, Avellini helped engineer a dramatic overtime victory against the Giants that put the Bears in the playoffs for the first time since 1963. Spirits ran high at all levels of the Bears organization as Finks's rebuilding program seemed to be on the right track. Unfortunately, the positive momentum was short lived and the Bears continued their up and down record until Avellini's departure at the end of 1984.

"The good thing was that I was able to leave on my own terms," Avellini said recently. "I was traded to the Jets which brought me back to the area where I was born and raised. That's where I was playing when I finally retired. Although it was a big adjustment for me to no longer be a part of professional football. Having friends and family around at that time made a tremendous difference."

After his playing days were over, Avellini tried a variety of business ventures before obtaining his commercial real estate license. He remains active in that endeavor in the Chicago area.

> My name may have gotten me in the door on those first business calls, but from that point on, I had to produce. It was a challenge to say the least. But commercial real estate is a fascinating career. I still miss being out on the football field, but I feel satisfied that I've been able to achieve a measure of success in business as well.

Avellini was always known for his calm under pressure while starting for the Bears. His view of the games he played versus the Packers during his tenure with the team still reflects that approach:

> To my way of thinking, going up against Green Bay was just one more game on the schedule. I never really understood what all the fuss was about. The coaches would tell us that we had to win those two games each season. But what exactly did that mean? That we didn't need to try as hard during the rest of our schedule? It's like somebody telling you not to worry about the Chiefs or the Vikings. It's the "putting all of your eggs in one basket" theory. That just didn't make any sense to me.
>
> As I saw it, every conference opponent was a worthy opponent. Those were all games that could make a big difference in your record by the end of the season. If you won and they lost, then you were two up. That was always good. Maybe I was too rational about things then, or even now. I know that the coaches certainly were emotional during that week leading up to a Packers game. They'd do just about

*anything to get us worked up. I guess those efforts just didn't work too well on me.*

*I was always a strong competitor. I didn't want any team to beat the Bears, no matter who it might be. Winning and losing were always quite clear in my mind. If we won, I was happy. If we lost, I was sad. It was just that simple. I didn't feel particularly intensified emotions either before of after a game just because we were playing Green Bay.*

*But one thing I did notice when we traveled up to Wisconsin was the nostalgia factor. Lambeau field was something else. We'd go through all of these neighborhoods filled with bungalows on our bus ride over to the stadium. Then suddenly, there it would be, Lambeau looming over everything. It was pretty hard not to be impressed by that sight.*

*How easy or difficult it was to play in Lambeau was dependent on the weather. You could get some balmy afternoons if you were scheduled to go up there early in September, but by the end of the season, it wasn't much fun. I remember game after game with the wind howling down the sidelines. It would be all I could do to get enough feeling in my hands to hold on to the ball.*

*Chicago always used to be penciled in for the last, or next to last game of their season. I guess the Packers, or the League, or whomever, thought we could handle things up there. Miami never had that slot. They were in Green Bay much earlier in the season. Maybe their blood was too thin from playing down there in the tropics all the time. But we were all from the same area, more or less, the Packers and the Bears. Soldier Field certainly wasn't balmy in mid December so the Packers had to suffer too when they came to town.*

*In my experience, Packer fans were always quite respectful. Sure you'd hear the occasional comment, but it wasn't any big deal. That's why I think in retrospect that the fierceness of the rivalry might have been exaggerated. The media had a lot to do with that, I suspect. Rivalries always seem to sell papers. The newsmen would be guaranteed that at least two weeks a season just about everybody in Chicago would be reading about the football games.*

*What bugged me then and still bothers me even today that players doing their jobs well from week to week were completely ignored by the press. If somebody messed up in a game against Green Bay, you'd definitely be reading about it the next day. Headlines, probably. The same thing if somebody did particularly well. But what about all the other weeks in the season? What of all the other players who just went out there and got things done? Not good copy there, I guess.*

*But I probably shouldn't be too tough minded on this subject. After all, there are generations of fans and players who felt, and still do, that Green Bay games were the height of our season. I'm just saying that for me personally, every game was important. Yes, the Packers could be formidable but they were just one more week on our schedule. I didn't give more effort against that one team than I did against any other.*

Bob Thomas was always a player the Bears could count on when the chips were down. Now he is starring in a very different arena, the State of Illinois Judicial System. Thomas, who played as a kicker for the Bears from 1975 to 1984, had his share of pressure situations and close calls on the field but currently finds that he is under a different type of scrutiny.

*By my third year with the Bears, I decided that it would be wise to begin preparing for an eventual non-sports career. I was leaning toward law school. Jim Finks and I discussed this at great length. Jim was very supportive in this endeavor and it was with his wholehearted encouragement that I enrolled in the night program at Loyola University in Chicago.*

Because of this professional athlete's unique schedule, he was able at attend Loyola full time during the off season, and part time during the fall. Thomas completed his degree in four years.

*I started practicing law part time in 1981. It was a very busy few years for me, balancing the demands of a professional football career with those equally demanding time requirements of an attorney. But it was a productive move ultimately. I was able to enjoy my two passions, sports and the law. I had the opportunity to build skills in the legal world while remaining on the Bears active roster.*

Thomas was released by Chicago in 1985 and subsequently signed with the Chargers. After a year with San Diego and another with the New York Giants, he decided to focus completely on the law in 1986. Shortly thereafter in 1988, he was elected a Circuit Judge. In 1994, Thomas was elected to the Appellate Court where he served for six years. In 2000, Thomas made the move into the Illinois Supreme Court where he will serve as Chief Justice in the near future. Being a judge and a former Bear has its advantages and its disadvantages, as Thomas has found.

*It's been a wonderful life so far. I lived out my dream of playing in the National Football League. Being a member of the Bears was my goal when was in high school and later when I played at Notre Dame. It was thrilling to have achieved that end. Then, to have this kind of success in a completely different endeavor after leaving football has been extremely gratifying.*

*The first time I ran for a judicial position, my name recognition probably was a great help. But now that I'm on the bench, I feel at times that I am being watched much more closely than I would have been had I not been a professional athlete. I've had to prove that I deserved the job.*

Known as a savvy and skilled player, Thomas still ranks third on the Bears all-time scoring list with 13 field goals. Many of them were made under less than ideal circumstances, as Thomas well remembers:

*Other players on the roster sometimes enjoy making fun of kickers. They say we're not physical enough or that we have too many quirks. I agree to some extent that we are a different breed from your ordinary NFL player, but the way we go about things is a necessary part of the job. To do well in this position, you need to be able to shut out every possible distraction and put all of your attention into the task at hand. Take climactic conditions, for example.*

*Kickers are so focused that they rarely allow themselves to be distracted by the weather. It can rain, it can snow, there can be a gale blowing off of the lake, but it can't make any difference in your ability to get the ball through the uprights. But every so often it would be so horrible outside that even the thought of having to go out there was frightening.*

*I remember once against the Giants, I think it was back in 1977, when the field was a sheet of ice. There was just no way to get a firm footing so I could get my force behind the ball. It was our big chance to make the playoffs for the first time since 1963 and the pressure was on. I had to go in there and block all of the discomfort completely out of my mind. I was able to connect and Chicago went ahead to win by a score of 12-9.*

*But an even tougher day was one time we were playing up in Green Bay, the end of December in 1983. I'd always loved that field. There was something historic and wonderful about being there. When we would come out of the locker room for the first time each year, I'd take a minute just to look around me at the people, and at the stadium itself. There was the sense there that everything that was about to happen meant something important. Lambeau had so much tradition that it was*

*almost overwhelming.*

*This particular time, however, it was brutal. As soon as I left the locker room, I just wanted to turn around and forget about the game. I've never been so cold in my life. The wind chill must have been -40, -50, something awful like that. My usual method was to come out about an hour before the game just to get warmed up and in my rhythm. Gary Huff, our backup QB, was in his last year with the Bears. He was my holder.*

*I went out on the field right on schedule and just stood there, freezing my tail off. There was no sign of Gary anywhere. I thought something probably held him up so I stood there absolutely freezing waiting and waiting. Finally, as I left to head to the sidelines, he came into view. I went up to him and said "Gary, what in the heck were you doing? I've been waiting so long out there that I'm completely numb."*

*Well, Gary just looked at me as if nothing at all was wrong and said "Johnny Unitas was on television. He's always been my hero so I had to watch it. Didn't think you'd mind." I was speechless as far as a suitable reply was concerned. It was so cold all I wanted to do was to find one of those sideline heaters and nestle right in.*

*The game was an important one, rumored at the time to be Bart Starr's last career start for Green Bay. The Bears would be 8-8 if we won, so there wasn't much at stake for Chicago except for the bragging rights if we won. If the Packers got the win, they'd be headed to the playoffs. As you can imagine, their emotions were running pretty high.*

*It got down to just ten seconds left in the game. The Bears were down 20-21 but we'd had a pretty good drive going. By the last series of the game we definitely were in field goal range. A time out was called.*

*I watched intently from the sidelines knowing that my chance would come soon enough. My first priority was to try to warm up. We had a punter who'd recently had been cut by Green Bay and signed by the Bears. He was furious that the Packers had let him go. He wanted to beat them so badly that he kept shouting in my ear, "use the net, use the net" meaning that he wanted me to take some practice kicks first.*

*I couldn't do that. Heck. I could hardly move. Never been so cold before or since. And you could be sure that there was just no way that I was going out there until I absolutely had to. I couldn't feel my hands or feet. I had no coordination left. My first priority was to warm my body any way that I could.*

*My customary spot along the sidelines in weather like that was directly next to the giant electric heater. I went over in that direction and who did I see hogging the warmth but McMichael. I asked him to get out of the way and he turned and glared, then made a few pithy comments in my general direction. He wouldn't budge an inch. Time out was over and I headed out on the field. Ten seconds left in the game.*

*Usually when you're all lined up for a last second field goal, the opposing players will shout and scream all sorts of nasty things at you, anything to break your concentration. This time it was completely different. They were begging me to miss. I couldn't believe my ears. I could even hear one lineman saying over and over "Please, Bob, just miss it."*

*I took a few steps back, stepped up to the ball, which by that time felt like a load of cement, and sent it directly through the uprights. Bears 23 Packers 21. The Packers fans went wild, screaming all kinds of obscenities at me. They were furious but I was just trying to do my job. The only thought I had on my mind the whole time was "ten more seconds and I can get out of here and into the locker room." But even now still I'm known as the man who kicked Bart Starr out of a job.*

Coach Mike Ditka and quarterback Jim McMahon, both sporting sunglasses despite the overcast sky, watch their team dominate from the Bears sidelines at Soldier Field. (Courtesy of Steve Woltmann.)

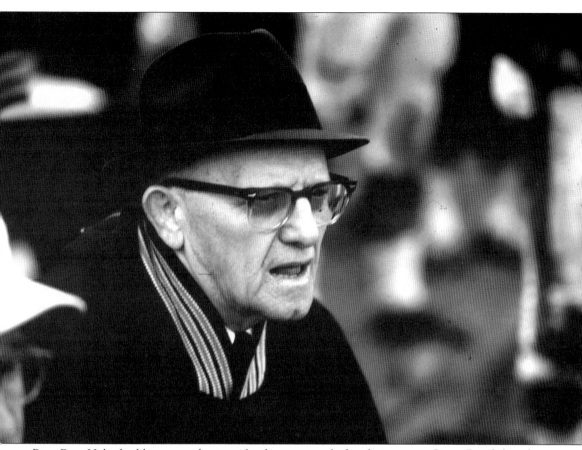

Papa Bear Halas had lost no enthusiasm for the game, or for his desire to see Green Bay defeated, after seven decades at (or always near) the helm. (Courtesy of Ron Nelson at Prairie Street Art.)

Walter "Sweetness" Payton (No. 34) and "the Punky QB," Jim McMahon (No. 9), would lead the Bears to new heights in the mid-1980s. (Courtesy of Ron Nelson at Prairie Street Art.)

Defensive tackle, William "the Refrigerator" Perry, used more than once—tauntingly—as an offensive wild card against the Packers, was a fan favorite of the 1985 Super Bowl XX Champions. (Courtesy of Steve Woltmann.)

# Ken Taylor
1985

Ken Taylor's rookie year in 1985 turned out to be a memorable one as the former CB and Punt Returner from Oregon State University found himself going from a college team ranked at the bottom of the Pac Ten conference into the high powered environment surrounding a Super Bowl contender. It was an adjustment that Taylor made with surprising ease considering the pressure on every member of the Bears that year.

"There was really an overwhelmingly positive momentum going for that team," Taylor said recently. "It was almost a sense of destiny. I felt it as soon as I first came to Halas Hall. Every member of the squad was united in this quest for the championship trophy. Although we knew that tremendous effort would be required of each and every one of us, we knew that we were up to the task. We simply didn't feel that we could lose."

The only glitch that the team experienced during its championship run was a loss to Miami, a setback that disheartened the Bears only briefly before they were back on track and headed towards New Orleans.

> *Looking back, that game we lost in Miami almost seemed to be in the hands of destiny and completely out of our control. Coming into the Dolphins stadium the first thing I saw was a row of Miami greats off of their '72 team standing shoulder to shoulder on the sidelines. I couldn't believe it. These were players I'd idolized while I was growing up.*
>
> *They never moved, never acknowledged us in any way. They stood there like statues, arms folded, glaring out onto the field. For many of us, and especially for me as a rookie, it was completely unnerving. I felt things go downhill from that point on.*

As disconcerted as Taylor might have been on that long ago night in Florida, once the team reached New Orleans for their final game, he was overwhelmingly confident.

> *When we heard that New England would be the team we'd be facing in the Super Bowl, we felt like we'd won already," Taylor said. "There was never any doubt that we'd win from that point on.*
>
> *We were able to shut out everything, the crowds, the media, all the distractions and just get the job done. I don't think that New England was able to accomplish that to such an extent. I'll never forget the expression I saw on Mike Singletary's face as we were about to come out of the tunnel that day. It was as intense a level of concentration as I've ever seen.*

The Super Bowl turned out to be Taylor's final effort for Chicago. Although he had enjoyed a successful season as a Bear, he was traded to San Diego and went on to play for the Chargers until his third major knee surgery forced retirement at the end of the 1987 season.

"I hated to leave, but my body told me quite clearly that there was no choice in the matter. Without two good knees, it's pretty hard to get much done." Taylor said. Currently Taylor owns and manages Athletes in Training in Portland, Oregon, where he works as a private and a camp coach for prep and college athletes in a variety of sports. Looking back on the Bears versus the Packers, Taylor laughed at his memory of a frightened rookie thrust directly into the center of an age old melee:

> *When I went against the Packers, it was my first time as a starter for the Bears. What a way to begin an NFL career.*
>
> *This particular game took place in Wisconsin. As soon as I arrived in town, I could feel the animosity directed towards our team. It was almost palpable. Although I'd come from a school that was playing football in one of the major athletic conferences in the nation, the level of competition in this game was far beyond anything that I had ever*

experienced. Our defensive coordinator, Buddy Ryan, seemed to feel that I was up to the task, so it was fine with me to get in there as soon as possible.

My assignment was to cover Packers great James Lofton. To say that it was quite a learning experience would be an understatement. From the opening play of the game, Lofton had that look in his eye, the one that clearly said "out of my way rookie."

I was astounded at the level of his physical skills, Lofton was big, fast and agile, almost impossible to defend. At one point of that game, I was running along the sidelines, trying to keep him from catching a deep pass. Before I knew what was happening, he bumped right into me and I felt a searing pain where his elbow had gone deep into my ribs. Then he motored right by and came away with a spectacular catch.

I limped to the sidelines and muttered something to Buddy about what I'd perceived to be Lofton's cheap shot. Well, Ryan just about took my head right off. He wouldn't stop shouting and waving his arms. I remember him ending with "Stop complaining and get right back in there you *&#*!" I didn't want to hear any more of that, so I turned around and headed back on to the field considerably chastened. For the rest of that season you can be sure I never again complained to Ryan about anything.

The sheer physical brutality was always an earmark of any game against Green Bay for me. It's amazing we didn't kill each other out there. I think that every other person on the roster would agree. Just ask Jim McMahon or Matt Suhey.

There were incredibly hard hits, many just on, or way over, the border of what was allowable in the NFL. In retrospect, it's surprising that more players weren't severely injured in those contests. There was an intensity almost beyond words. It was more of a feeling than a thought process.

The rivalry was something we all learned about on our first day with the team. It was ingrained in us by the coaches and the veteran players. No matter what happened in any of the other games, we were told quite clearly that any time we went up against the Packers it was a must win situation.

All of us took this quite seriously on both a personal and a professional level. Even that day when we were walking into the Super Bowl I don't remember being as nervous as I'd been the two times I played against Green Bay.

But looking back from the perspective of today, it was all incredibly cool. There I was, an undrafted player fresh out of last ranked team in the Pac Ten. Nobody but a few NFL scouts had ever heard of me, but I made it to the pros.

And once I made it to Chicago, things got even more interesting. I played for Mike Ditka and Buddy Ryan on one of the most dominant lineups ever assembled. My first start was against the Packers in their home stadium. My last game for the Bears was a victory in the Super Bowl. It just doesn't get any better than that.

Bear quarterback, Jim McMahon, drops back for the pass. (Courtesy of Steve Woltmann.)

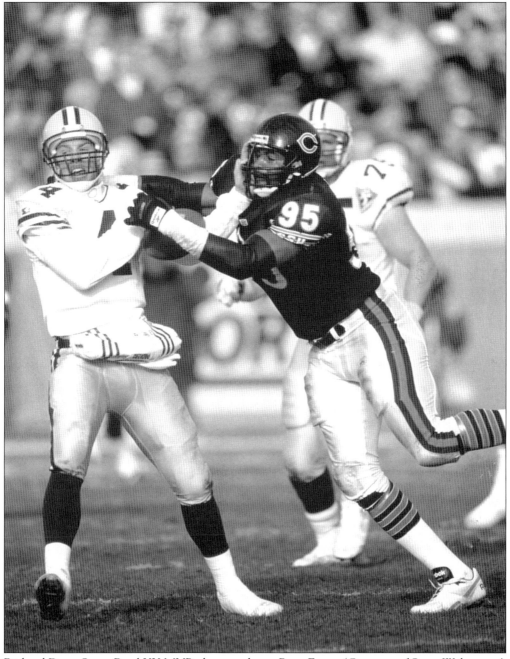

Richard Dent, Super Bowl XX MVP, closes ranks on Brett Favre. (Courtesy of Steve Woltmann.)

# Mike Tomczak
1985–1990

Big time football wasn't anything new to Mike Tomczak when he came to the Bears as an undrafted rookie. At Ohio State University, Tomczak was known as a tough competitor and a savvy play maker who was able to lead the Buckeyes to two Big Ten championships.

Tomczak made an immediate and long lasting impact as an undergraduate athlete, garnering the attention of a considerable number of NFL scouts. Always able to remain cool under pressure, Tomczak's trademark move was the deep downfield pass. His college record of 376 completions for a total of 1,569 yards and 32 touchdowns still stands second on the Buckeyes All-Time list.

Despite remarkable success during his first two years as a starter, achievement on the field didn't always come easily to Tomczak. His biggest setback during college was a severe leg fracture incurred during the spring of his junior year. Showing both determination and physical resiliency, Tomczak battled back to regain his starting spot on the roster, ultimately leading his team to the Rose Bowl as a senior.

During 1985, his first year with the Bears and his initial year in the league, Tomczak played in a total of six games, including some memorable on-field minutes during the last quarter of Super Bowl XX. "From the Rose Bowl to the Super Bowl, not too bad for one year," Tomczak noted.

Tomczak had strong competition for the starting spot during his years with the Bears. He started seven games in 1986 and four games in 1987. He then was called upon to substitute for an injured Jim McMahon in three more outings during the 1987 season.

Tomczak's most talked about appearance in 1988 was the Soldier Field based "Fog Bowl" playoff game versus the Eagles when neither he nor his players were able to see more than a few feet down the field, a game he viewed at the time as "an interesting challenge." In 1989, Tomczak had 11 starts, with Harbaugh spearheading the remainder of the schedule.

In 1990, Mike Ditka designated Jim Harbaugh as starting QB in place of Tomczak, but Tomczak started in the last two games of the regular season plus two subsequent playoff contests. It would be the veteran QB's last appearance with Chicago before being released at the conclusion of that season. After leaving the Bears, Tomczak was promptly signed by Green Bay.

> *What a strange feeling coming out on to Lambeau Field for the first time in a Packers uniform. I wasn't sure if the fans were going to boo or cheer for me. But I settled in pretty well. Even though the Bears and Packers were longtime rivals, it wasn't incredibly difficult to make the transition. It's the type of adjustment that's part of life in the National Football League.*

Tomczak remained with the Packers for a season, then signed with Cleveland in 1992, and finally moved to Pittsburgh in 1993. He remained with the Steelers through the 1999 season, then relocated to Detroit in 2000 where he was to have been a backup to Charlie Batch. After breaking his leg before the start of that season, Tomczak retired from professional football. He now works as an analyst for ESPN and Fox Sports Net.

> *Sure, I missed football when it came time to leave the game. That had been so much of my life up to that point. But my undergraduate major was communications so it was a matter of getting back to my roots in a way. I truly enjoy my current profession. It's a wonderful opportunity to put all that I learned during those years in football to good use.*

And after 16 years in professional football, what was one of Tomczak's fondest memories? The food in Lambeau Field's visitor's locker room. Tomczak tells the rest of the story:

The bullion . . . that was my favorite part of going up there to play. I don't know why it was so good, but it was the best soup I've ever had. The perfect touch for a long physical day. It was prepared by the longtime attendant we used to call Squeaky. His voice was pretty high and that's how he sounded. I don't think that Squeaky took offense at that name, it was just the way things were.

Coach Ditka made no bones about what he expected from us whenever we went against the Packers. He knew from his playing days that it would be a hard fought contest. He wanted to be sure that his guys came out on top. If not, there'd be hell to pay.

Ditka and Forrest Gregg had something going on most of the time they faced each other. They just didn't like one other one bit. It seemed more intensely personal that what you would normally expect to find with the Chicago-Green Bay rivalry.

I wasn't unfamiliar with big games, after all, we'd had plenty of them when I was on the Ohio State team. To my mind, at least during my first year in Chicago, this wasn't that much different. But the longer I remained with the Bears, the more I understood the history behind this whole thing. It was passed down from veteran to rookie over the years as part of our initiation into the team. The older players in Green Bay did the same thing with their rookies.

Ditka always wanted us to play right at the limit of what we could get away with on the field. He never advocated getting penalties, in fact, he'd be livid if we did get caught, but he expected our full effort every minute that we played Green Bay. He always told us "Make the hits but be smart about it. Make sure that what you do is legal."

You never knew for sure what was going to happen. "It is what it is," that's what I'd think when I was getting ready to go out on the field. You couldn't control things, so you just went with the flow.

Sometimes on-field action went way over the line of sportsmanlike play. I remember those late hits on Matt Suhey and McMahon. I remember Payton being hurled into a Gatorade container. I remember Charles Martin trash talking about his "hit list," and the numbers that were written on his arm or his towel. They'd be the guys he was going after that particular day. These were games at an entirely different level. I remember incredibly hard hits, brutal plays that I'd feel throughout my body for days afterwards.

The sidelines were a real hazard, particularly if you got near the Green Bay or Bears equipment areas. Unlike most games where your opponent would cushion you a little if you were out of control physically and are heading straight toward something hard, nobody came to the rescue in those games.

If you were going right at the Green Bay bench, the players there would get up and move out of the way, then watch you as you hit headfirst into their seats. And nobody would help you up once you went down. You were completely on your own. The Bears did the same thing when their turn came. Also you never, ever wanted to be at the bottom of one of those piles if you were tackled. I can't tell you some of the things that happened there.

Sometimes funny things occurred. I remember back in 1986 when Kevin Butler had the chance at a last minute field goal that would win the game for us. Green Bay called a time-out to "ice" him. I was on the field to be his holder.

It had been a cold, rainy, miserable afternoon and the field was a bog. When nobody was watching during the time-out, I stayed in my stance and I built this nice little mud pyramid to hold the ball and give Kevin a better angle. Even though it was well over an inch high and fairly wide, Kevin didn't notice it, so I went over to him and said, "just pay attention to where I place this football." He chipped that ball in for the win.

There were some good times playing Green Bay and playing for Green Bay, and some not so good times, too. But I think that with some notable exceptions, once the games were over, there was a level of mutual respect between the players of both our

*teams. We could be friends off the field despite the magnitude of that rivalry. Those friendships grew out of shared experiences and physical effort. When everybody is out there giving it all they've got, that's something to feel good about. It's what the National Football League is all about.*

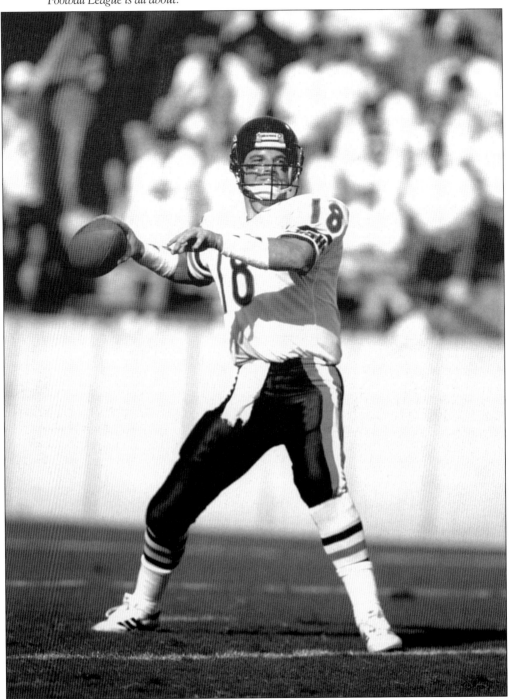

Mike Tomczak drops back to pass. (Courtesy of Steve Woltmann.)

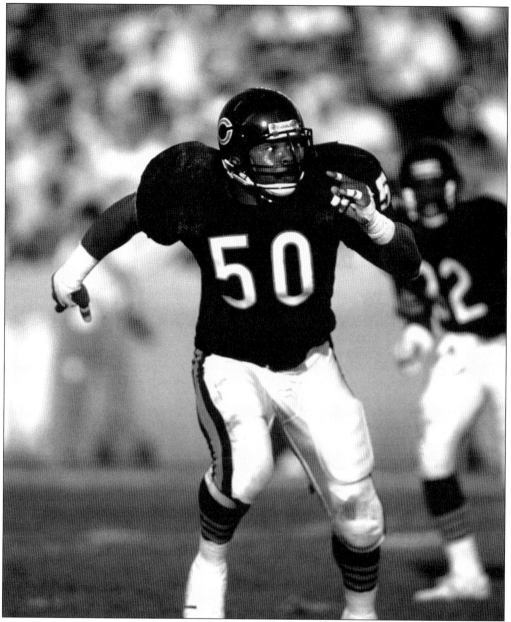

Hall of fame linebacker Mike Singletary zeros in on the Green bay offense. (Courtesy of Steve Woltmann.)

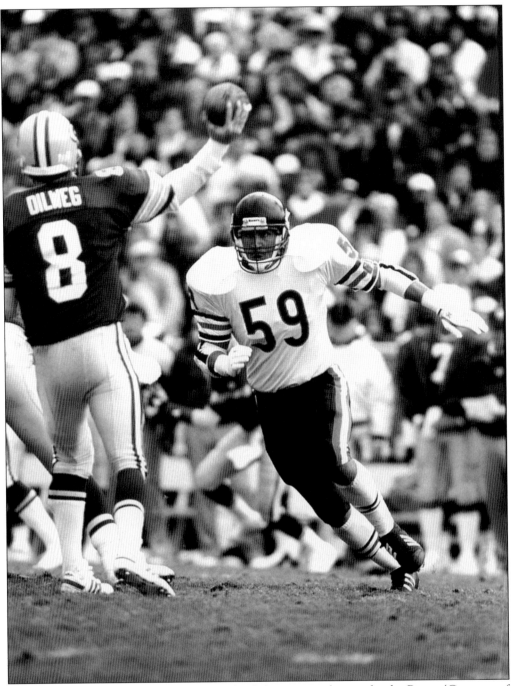

Defensive powerhouse Ron Rivera is now the defensive coordinator for the Bears. (Courtesy of Steve Woltmann.)

If you're a Bears fan, or even a Packers fan, you've probably seen Don Wachter either in the stands or on the field. This charter member of the fan section of the Football Hall of Fame has been rooting for his team as long as he can remember.

Wachter's journey to Canton began with a 1998 phone call from Visa to every team in the National Football League. Each organization was asked to select a "super fan" to be represented. As Wachter tells it, Ken Valdesseri, then marketing manager for the team, had seen him cheering at games.

"I always got kind of loud, but in a good way," Wachter says. "My photograph waving a Bears flag appeared in one of the Bears calendars and also on the cover of the team yearbook. Bears management definitely knew that I was around."

Wachter's next step was to write an essay stating why he should be the fan chosen to be honored.

> Fans from each of the then 31 teams did the same thing. The winners were then selected and notified by Visa and by the teams. I thought at the time that this was important, especially for Chicago's fans. The Bears had no mascot then, so it was nice to have the team's boosters recognized in a meaningful way.

Wachter eventually got a sought after volunteer position on the sidelines wearing blue and orange face paint, dressed in a Doug Plank tribute jersey and sporting a Bears head as a hat. When that job was phased out as the new Soldier Field opened and Staley the Bear was selected as the team's official mascot, Wachter became the flag bearer on the northwest side of Soldier Field. He's seen many Bears-Packers games and shares some of his thoughts on the rivalry:

> From the first time I was in the stands as a ticket holder for a game, Chicago-Green Bay was the one I always looked forward to. No matter how either team was doing in the overall rankings, fans always knew that they would be watching one heck of a game.
>
> Just going into the stadium on those days you could sense the energy all around you. If it was a home game, the fans would be very vocal in their dislike of the Packers. Of course the reverse was true when we traveled up to Green Bay.
>
> I was always surprised at how cordial the Packers fans were to Bears supporters. I got to be friends with Puckalope, the unofficial Packers mascot. When I'd go up to Wisconsin, we'd walk through the stands and along the sidelines before the game would start.
>
> Frankly, the first time we did this, I was more than a little concerned. I wasn't sure exactly what the reaction to my presence there would be. But everybody there was incredibly nice. They didn't like the Bears of course, but they seemed to respect my allegiance. I'm sorry to say that wasn't always the reaction that Packers fans received when they visited Chicago.
>
> Maybe it's the fact that the Bears haven't fared well in the series recently, but I've found that Chicago fans can be more than a little hard on anyone wearing a Packers jersey. Of course I realize that a lot of this is just in the spirit of the rivalry and the inherent competition, but sometimes it tends to go a little bit over the line. I've heard Green Bay people booed and have seen objects thrown in their general direction. I certainly believe fan enthusiasm is a wonderful thing, but there are some lines you just don't want to cross.
>
> Being down on the field during a game is about the most exciting thing that can happen to a true football fan. There's something about the energy there that is difficult to describe. There's a noise level that comes and goes in waves depending on what's happening out on the field.

Then there's the sound of the hits, the whoosh of a hard thrown ball, the signals being called out. There are so many experiences happening all at once down there and it can be overwhelming. No matter what's going on, it's always exciting.

My earliest memory of a Bears Packers game was a 6-12 loss at Green Bay back in 1980. There was a blocked field goal that the Packers grabbed and ran in for a score. It was just terrible. The Bears got revenge, though, in their next game against Green Bay when they had the Packers down by a score of 61-7. Sweet revenge here in Chicago before a home crowd of almost 58,000. You can imagine the noise level in that stadium after that game.

Then there was the famous Halloween night game. It was bitterly cold out and raining so hard it was coming down sideways. What I noticed as the quarters progressed that more and more fans left the stadium, but none of them were Bears fans. This was when the Bears were getting their asses kicked 6-33, but most of us stayed until the bitter end. I guess that says something about team loyalty and support whenever Chicago is facing Green Bay.

I remember so many scenes from these games. Ditka yelling on the sidelines. McMahon getting a late hit and going down hard. Payton heading toward the sidelines with such momentum that he ended up in a heap clear on the other side of the Bears bench. There was always tremendous effort on both sides of the field.

In recent years I've noticed the intensity level changing somewhat. Playing Green Bay seems to mean less to both the fans and the players. I heard one of the Super Bowl XX guys talking on sports radio the other night and he said that he'd noticed the same thing.

Perhaps the "fire" over this rivalry isn't coming down from the head coach, or maybe it's just because the players change teams more often now. You see these young guys going from city to city where before they would stick with one team for eight or ten years at a time. Things don't really get a chance to develop emotionally in terms of the rivalry. I guess it would be difficult to become too engaged if you felt that you were only going to be with the team for a matter of months.

But I hope that some players and fans continue to care. This is such an important part of the National Football League and it should be at the core of every true Bears or Packers fan's heart.

There were a lot of milestones and memories over the years. There are so many moments fans can savor even today. My favorite games have always involved these two teams. It's pure football in the traditional sense of the game.

A familiar sight to fans at Soldier field was Dan Watcher with his trademark Bears flag. (Courtesy of Dan Watcher.)

If you happen to see a bright green and gold mini van with a large fiberglass cheese wedge on top driven by a man wearing an old time football helmet decorated with antlers, chances are it's the vehicle belonging to the self proclaimed "Packalope," the unofficial mascot of Green Bay.

The Packalope, who is known in non-football circles as Larry Primeau, evolved from a costume that Primeau and his late wife Sue devised to show their support for the home town team. Sue, who was often called Mrs. Lope, came up with the moniker for the pseudo mascot after watching an episode of American's Funniest Home Videos that featured a mythical creature, the Jackalope.

The Packalope concept attracted such favorable attention that Primeau and his getup were commemorated in the Visa Fan Hall of Fame section of the NFL Hall of Fame in Canton, Ohio. Fittingly, his image was joined there by that of Bears superfan, Don Wachter. Wachter and Primeau have also been in commercials together and have appeared on National Geographic Television.

Although Primeau had been a longtime ticket holder at Lambeau, once he became the Packalope, a change in seating venue had to follow. Because of problems fitting antler headgear into Lambeau's already tightly packed stands, the Packalope's favorite lair soon became Lambeau's perimeter tailgating lot.

No matter what the weather, Larry and his distinctive mode of transportation occupy a centrally located parking space, waiting to greet the Packer faithful at a seemingly unending party.

"It's a festive atmosphere," Primeau said. "And it's a great place to meet the fans. The huge cheese wedge on the roof makes it easy for anybody to spot my space. There are regulars who come by every home game. I even decorate the van for holidays. For example, during the Christmas season, I provide a tree completely adorned in green and gold. People who support the Packers love that."

Primeau's own family home is also a shire to all things Green Bay, including "just about every piece of memorabilia that's been available since the early 1970s." But are there any items Bear related? "Why yes," Primeau says. "I have a fake Bears head. It says right on the snout 'Bears Suck.' Does that count?"

Although the Packalope doesn't take his show on the road, fearing with good reason that a foray into Bears territory might end in automotive disaster, Chicago fans can see what all the fuss is about the next time they venture north of the border.

"Just look for the huge cheese in the Lambeau lot," Primeau said. "Anybody is welcome to stop by. Just don't wear too much of that blue and orange."

Primeau tried to be neutral when speaking of past Bears-Packers contests, but soon reverted to true form, admitting that he wasn't too sorry that Green Bay had been the dominant team "for most of recent memory." He did, however, acknowledge some less than above board tactics his home team might have used in the past to come out on top:

> I've been going to games faithfully since 1973. I've seen a lot of good football during those years, and some of it (but not much) was on the part of the Bears. OK, I'll admit it. At times the Packers tended to play a little rough. I'm sure that everybody who has ever followed Chicago's fortunes can remember the time that Cecil Martin went after McMahon well after the whistle had blown. I thought every Bear on the field was going to lay into Cecil that day. Perhaps Martin was just hard of hearing and didn't intend to break any football rules. It stopped the Bears for a play or two, though.
>
> Another instance that comes to mind was the shot that Matt Suhey took. One of the Packers took off after him considerably after the play was dead. I'm fairly certain that I remember this particular member of the Green Bay roster not even being legitimately on the field, but coming off of the bench to make the final hit instead.
>
> In no way do I intend to make light of Suhey's injuries resulting from this action, but I've often wondered if, should opportunity ever present itself, one of the Bears might some day retaliate in a similar fashion. Those are the kinds of things that can happen in a Packers-Bears game.

Even the coaches tried to get into the action from time to time. There was no love lost between Halas and Lombardi. Back in the Gregg-Ditka days, Forrest and Mike themselves would have jumped from the bench and torn each other apart if they'd had the chance.

Even Bears great Walter Payton was not immune to some after-whistle roughness. I believe it was Mark Lee who was running along the sidelines with Payton at the conclusion of a play. He had hold of Walter and just wouldn't let go.

Walter wasn't giving up the fight either. No Packer was going to push him around. The end result was that both of them went hurtling over toward the Bears bench. Payton wound up being pushed into the Gatorade container. It was an incredible mess, with that colored liquid flying all over the place. There in the middle of it all was Lee still grabbing Payton. If the other players and the refs hadn't separated the two players, they would have continued the fight for hours.

But not all Bears and Packers are enemies. I've become friends with Don Wachter, the fellow who used to be on the Bears sidelines wearing the Doug Plank jersey and the bears head. It's always been fun to wander around at games with him here in Green Bay just to see our local fans reactions. I think he's gotten a little nervous at times, surrounded by all of us, but nothing untoward has ever happened.

For the most part, I believe those of us here in Green Bay have been hospitable, far more so than would be the case if the situation were reversed. Chicago's fans make me uneasy. I've always had the fear that if I ever appeared in Soldier Field with my Packalope outfit and the cheese-topped van, one or both of us would end up in the Chicago River. It seems to me to be a wise decision for the Packalope to stay home, right here in Green Bay.

The Packalope, Larry Primeau, poses in front of his cheddar-topped van. (Courtesy of the Packalope.)

Even the most diehard Bear fan and Packer fans can get along, as proven by Wachter chumming it up with Mr. and Mrs. Packalope. (Courtesy of the Packalope.)

# Tom Waddle
## 1989–1994

Heart, and sometimes desperation, can overcome a perceived lack of talent on the football field. Just ask former Bears wide receiver Tom Waddle.

"I never was that athletically inclined in college or in the pros," Waddle said recently. "I wasn't real big, I wasn't terribly fast but I had the desire. So to succeed, I had to compensate for my shortcomings. What worked for me was to give up my body for the play. In my mind, that was the only way they'd keep me on the roster."

But despite Waddle's inclination to believe otherwise, Bears fans who watched the scrappy receiver as he played felt that he was the heart and soul of the team. More often than not, Waddle could be counted on to make the seemingly impossible catch, frequently being battered by defensive behemoths in the process.

Waddle took hard hits with surprising frequency. More often than not, he'd bounce back up after being upended and sent careening into the turf. Sometimes, however, things got too rough, even for Waddle. During parts of the season, it seemed as if his visits to local hospitals for treatment of a wide assortment of injuries would equal the number of big plays he made on the field. But nothing seemed to discourage him from returning to the fray. No matter what happened, Waddle remained undaunted.

"Sure, I got beaten up a little bit," Waddle said. "But to me that was all part of the game. If you're not willing to sacrifice to get the job done, then you don't belong in professional football."

For head coach Mike Ditka, Waddle was the prototypical Bear, a modern-day Monster of the Midway. "We got along pretty well," Waddle said. "To Ditka, I was a real Grabowski, a lunch bucket kind of a player. My guess is he felt that way because although I knew I wasn't that good, I was always in there trying."

Waddle had several hundred yard games during his career, and remains in the Bears All-Time record book for annual receiving yardage with 44 catches for 552 yards and one touchdown in 1993. His career totals with the Bears were 173 catches for 2,109 yards and nine touchdowns—impressive stats for a player who never really believed that he had the skills necessary to succeed in the NFL.

And although never a full fledged star in his own mind, Waddle was an enduring favorite with fans, a fact that helped him transition into a successful career in sports broadcasting booth during his final years with the Bears and after his retirement from football.

Still active in Chicago sports media, Waddle can be counted on to tell the straight story from a player's point of view. Although following his former team can become "a very emotional journey at times," Waddle feels fortunate to have the opportunity to stay close to sports and to remain in Chicago.

> I've been incredibly lucky so far. I have a wonderful family and I'm living in a city I love. Playing for the Bears was something that I'll never forget. I met some unforgettable characters and got to know some men who have become friends for life. Just being there was such an incredible experience. I was grateful for every minute I had on the field, even if the end result was a trip to the emergency room after the game.

But one of Waddle's least favorite memories involved the Halloween night game against the Packers in 1994:

> That was one of the worst nights of football that I can remember, which is saying a lot because I played for quite a few years. It was held in Soldier Field. There was a pretty big crowd there, probably a sell out, which was something I didn't really understand at the time because the weather conditions were horrible. I guess that was a demonstration of just how important the rivalry is to Chicago and Green Bay fans.

It was incredibly cold and the rain was pelting down on us, practically going sideways because the wind off the lake was so strong. As soon as we took off our warm-up jackets, we were soaked. I was sure that any minute it would begin sleeting. It was that close to freezing on the field. At times it got so bad that we could barely see the ball. If you were trying to catch something down field, it was close to impossible.

What made it even more awful was the fact that the game was a total blowout as we lost 6-33. We couldn't do anything right that night. So not only did our fans have to risk pneumonia to watch us play, we didn't even give them a decent show.

The worst moment of all was when Butkus and Sayers were having their jerseys retired. It was supposed to be a wonderfully dignified ceremony commemorating those Bear heroes, but they were drenched and shivering on the sidelines, eager to just get the thing over with. At one point, Butkus and Sayers ended up sort of wrapped in these big black garbage bags in a futile attempt to keep dry.

It was the most bizarre sight I've ever seen. The stadium was quiet and all eyes turned to the former players. Unfortunately, all that was visible of either of them were two huge black bags with heads, arms and legs sticking out here and there lumbering out on to the field. The ceremony was still meaningful to them, but I always felt terrible that they should have been honored on a night that turned out like that. But it figures. Things often ended up like that during games against the Packers.

I went to Boston College as an undergrad so the rivalry didn't mean much to me when I joined the team, but the veterans soon set me straight. Coach Ditka did, too. He was very clear about that. It was drilled into our minds that those two games were must win situations. Ditka was always a strong guy but I know his intensity was measurably higher whenever we saw Green Bay.

Playing the Packers you had to suck it up, go out there and do your best. I knew the Green Bay defense was tough, so I would just try to figure out a way to get around them. Sometimes it worked quite well, sometimes it didn't.

But the tradition was something that I always respected. These two teams were the backbone of the league. There was so much history there. Perhaps some of it is getting lost as younger players are coming in to the game. I hope not. The Bears-Packers rivalry made those meetings special and memorable. It's something that I appreciate, even to this day.

# Jim Flanigan
1994–2000

Jim Flanigan came to the Bears during a time when Chicago had a mediocre record against Green Bay. In fact, during 1994, which was the young defensive tackle's rookie year, the Packers came out on top twice by resounding scores, 33-6 in Soldier Field and 40-3 in Lambeau. Flanigan took the losses hard.

"From my very first day in Chicago, the veterans made a point of teaching us all about the rivalry," Flanigan said recently. "Those were the two games every season we just had to win. Nobody took things lightly during Packer week. There was even a sign in the locker room that said 'Redeem Yourself. Beat Green Bay.' That was an indication of how serious every member of the team was about the rivalry."

For Flanigan, however, contests against the Packers were a mixed blessing. His father, Jim Flanigan Sr., had been drafted by the Packers as a linebacker in the second round of 1967. Growing up, the Packers were not only a team to root for, but a way of life.

Flanigan Sr. remained with Green Bay through the 1970 season, a time during which young Jim remembers wearing green and gold on each and every football Sunday. Even after retiring from football in 1971, he became an active member of Green Bay's civic and business community. The family had strong roots in the area and enduring ties to the Packers. "Once a Packer, always a Packer. That was true for each player," as well as for their entire family, young Jim recalled.

To say that a major mental readjustment was in order when young Jim donned blue and orange for the first time would have been an understatement. "I was so excited to be a professional football player, but I was more than a little surprised when I looked in the mirror before that first game." But Jim was able to separate sentiment from his role on the football field, and was a dominant force whenever the team went against Green Bay. And although he had first learned about the rivalry from the other side of the field, once he came to Chicago, Flanigan became a Bear through and through.

"Football is football and you go all out for the team you are playing for," he said. "Once I was out there and the clock started, I wanted to beat the Packers just as much as anybody else on the team."

Flanigan played for the Bears through 2000, then joined the Packers in 2001. He moved on to the 49ers in 2002, then retired from football in 2003. He left with no regrets and still enjoys his unique status as a member of the roster for two of the NFL's founding teams. Flanigan relates some thoughts on the rivalry:

*I may have grown up in Green Bay, but I went to Notre Dame, so I had a chance to view the Bears from two very different points of view far before I joined the team. Of course, living in Wisconsin with my father a member of the Packers, there was no doubt where my early allegiances were. In college, though, it was so much fun to watch Notre Dame grad Chris Zorich playing for Chicago that I began to view things differently. Chris was one of many from that school who have been with the Bears. I was proud to follow in the tradition.*

*I was drafted by the Bears in the third round of 1994. My family and I were really excited about this opportunity, although I suspect my father would have been even happier had I been picked by Green Bay.*

*I took to the area immediately. It was fun to be so near such a large city. Chicago had so many advantages that you just couldn't find in a small town in northern Wisconsin. During the off season, I got involved with several business ventures and also had the chance to start my foundation. Just as my father had done in Green Bay, I wanted to give back to the community. I greatly enjoyed my time with the team and was sorry when it came time to leave.*

*When I played for the Bears, it seemed that the fans were a forgiving lot on the whole. We were having a tough time but they seemed to stick with us no matter*

what. Our record during those years certainly was not great against Green Bay. We lost both meetings in 1994, 1995, 1996, 1997, and again in 1998. It wasn't until the first game of 1999 that we beat the Packers 14-13, but then Green Bay won once more in December of that year.

Each year at the start of the season, fans we'd meet would just have the one request "please beat Green Bay." Believe me, we tried and it became incredibly frustrating not to accomplish that goal.

In 2001, the year I played for Green Bay, I was again on the winning side as the Packers came out ahead 20-12 and then 17-7. I was happy to win but sorry for the guys from the Bears.

It was strange to all of a sudden switch allegiances for those games. Yes, I was a native of Green Bay but during my years in Chicago, I became a part of that city as well. I had many friends there as that had been my home since graduation from college.

Returning to Green Bay proved interesting. As a former Bear, I was a very valuable commodity for the Packers. Anybody who went from one of the two teams to the other was in that same situation. I'd sat in on seven years of meetings in Chicago. I knew the players and the coaches, and most important of all, what was in the playbook. There is no way that knowledge like that wouldn't help your new team.

As a fan you might assume that the Bears would change everything when they knew I'd be playing for Green Bay, but that wasn't the case. In fact, everybody just went in with the usual schemes and hoped for the best. Why? Because it's just not practical any other way. Players switch teams so often that coaches would have to spend all of their time working things around. Nobody at the top level of professional football has time to make alterations of that magnitude for one or two games.

I left football in 2003 after a year in San Francisco. I was ready to go into a business environment and wasn't sorry that my career in professional sports had come to an end. I returned to Green Bay to begin another phase of life. You just get to a point in time where other priorities, like your family and friends, begin to take precedence. Or that was my experience, anyway.

But you know what I miss most? The competition. When you've had the chance to play for both the Bears and the Packers, you've been there at the highest level of the National Football League. The adrenaline rush on the days that those two teams came together was like nothing else I've ever experienced.

I'm an agent now, working with young football players from my office in Green Bay. Having been a player myself, I think that I can give these athletes an insider's view of the NFL. I particularly enjoy working with offensive and defensive lineman. There's a certain mindset to those positions that I truly understand.

What I try to do with these recruits is to give them the same head start that my father offered to me. I tell them about the ins and outs of life in the League, often using both the Bears and the Packers as examples.

The tradition between the two teams goes way back yet it still lives on and that's a wonderful thing. What I experienced in Lambeau and at Soldier Field was pure football in its most basic form. There were close friendships, bitter enemies, and hard fought battles. Nothing was ever easy. The lessons I learned and the experiences I had during those years have given me a tremendous advantage in life.

John Mullin has been covering the Bears from the conclusion of the Ditka era into Lovie Smith's tenure. During his career, Mullin has won numerous awards for excellence from the Pro Football Writers Association of America and the Associated Press Sports Editors, as well as an Emmy award for the Bears pre game show on Fox-TV.

During his years of reporting, Mullin has observed many great moments in Bears team history, but few had the impact of the Payton Tribute Game. Here's what it was like on the sidelines and in the locker room that day:

*The tone for that particular game was set well before the Bears left Chicago for Green Bay. It was during the emotional farewell tribute to Walter Payton at Soldier Field shortly before the team headed north that the meaning of the occasion truly began to register in the minds of the players and Bears fans.*

*Dan Hampton's tribute to his longtime friend during the memorial service was probably the defining moment for everyone who was in attendance that day. Dan has always been known as a man who feels things deeply, but not as the most sentimental person you'd ever meet. Seeing a player so tough struggling to hold back the tears as he spoke of Walter was an experience that is hard to describe even today.*

*Hampton's most memorable quote that day came as he concluded his remarks and spoke about his daughter. "I have a little girl four years old," Hampton said. "Ten years from now when she asks me about the Chicago Bears, I'll tell her about a championship and I'll tell her about great teams, great teammates, and great coaches, and how great it was to be part of it. But the first thing I'll tell her is about Walter Payton."*

*It would have been pretty difficult not to have been moved by something as heartfelt as that. In retrospect, I suspect that Hampton's words might have had the most effect on those players who never had much of a chance to know Walter well. And that factor might have made the difference in the game that weekend against the Packers.*

*As the service concluded and the song "I Will Remember You" came over the stadium's loudspeakers, it was a moment overwhelming in its emotion. There was complete silence in the stadium, quieter than that venue had ever been, as everyone stood in remembrance.*

*This was much more than a farewell to a superb athlete. It was the chance to say goodbye to someone who was synonymous with the best of the Bears tradition. To most who were there that day, Payton was much more than a football player, he was the embodiment of all that was legendary about the Chicago Bears.*

*As the players filed out and headed to their bus, there wasn't a dry eye in the stadium. Those who had been Walter's close friends were clearly having difficulty keeping their composure while most of the newer players were just letting the moment sink in.*

*Then suddenly in the midst of that eerie silence, came the chant, first softly, then increasing in volume from the fans in the stands: "Beat Green Bay."*

*There was no way the players could have missed that message. The way to truly honor Walter would be to beat a highly favored Packer squad. Sentiment and sadness would have their time later. Now was the opportunity to respect Payton in a way he would have wanted-with the win.*

*I can only imagine what the ride up north was like for the Bears players and staff but whatever transpired, all of the Bears who had been at the service seemed to have pulled themselves together emotionally by the time the team came into their hotel.*

*The Bears weren't favored that weekend. While there was always hope that an upset could occur, I suspect what most there wished for was to at least make a good showing against the Packers.*

Lambeau Field was jammed with fans as was always the case when these two teams met. But something was different this time around. Along with the usual jibes against Chicago by the Wisconsin locals, there was a sense of sadness and respect even from the diehards wearing Packer colors. But that didn't mean the Green Bay supporters would concede the game out of sentiment. Once the first play began, everyone there was ready for war.

On the first or the second series, Cade McNown went down hard, ruining his knee. Jim MIller came into the game as somewhat of an unknown quantity. Miller hadn't done that much that was impressive in games up to that point, but his appearance in the lineup had a definite positive effect on the morale of the team. Where the Bears had been unable to gain much headway down field earlier, they slowly started to progress.

On the sidelines there wasn't the constant "win this for Walter" talk going on that you might have expected. Probably everybody on the team was worried about "the Piccolo effect" which was what happened when Brian was in the hospital and Gale Sayers came to see him. Sayers promised to dedicate the next game to Piccolo, which the Bears promptly went out and lost. Nobody wanted that to happen right after Walter's passing.

The game was hard fought and went down right to the final minutes. With the clock ticking to the conclusion, Favre drove to the Chicago 20 and ace Ryan Longwell took to the field to begin the kick for the game winning goal against Chicago. The Green Bay fans went wild as a 16-14 Packer win seemed a sure thing. Longwell rarely if ever missed his attempts, particularly from such a short distance.

The Bears and the media representatives stood on the sidelines willing the kick to go wide but almost certain that it wouldn't. It was one of those moments when you really want to watch but are afraid of what you'll see. Some turned away, others looked at the ground, while the bravest among us held our collective breath, watched every second unfold. The ball was snapped and . . . Longwell missed. It was suddenly as if time stood still. For a few seconds everyone and everything in the stadium seemed to be frozen in place. It was a surreal sight.

Then suddenly a huge roar erupted starting with the Bears bench and spreading quickly on to the field and into the Bears fans sections throughout Lambeau. Players were jumping up and down hugging each other, delirious with joy. Many had tears in their eyes, as did quite a few of us who were reporting the event. I've been to many games and have witnessed countless dramatic moments, but never have I seen anything like that.

Bryan Robinson, who was never known for his vertical leap, had somehow lifted his massive body just enough off of the ground to get a hand on that ball as it sailed toward the uprights. How did he do it? Even Robinson himself had no idea, stating after the game that he was certain some type of divine intervention had been involved. "Something or somebody lifted me up," Robinson said, shaking his head, uttering the same phrase over and over again to just about anybody who would listen.

The ball bounced harmlessly down on to the field and Tony Parrish covered it with his body. Game over. Bears win 14-13. Was Walter somehow involved in the outcome? You'd have a hard time convincing anybody who played that day that Payton didn't have a hand in the way things turned out.

Even players who had been around the league for years and were by and large pretty hardened characters swore that it was a moment like no other they had ever experienced. I guess nobody will ever know for sure what happened that day or why, but it was a defining moment for everybody fortunate enough to have been there. Thanks, Walter.

# Two

# ALL-TIME RECORD

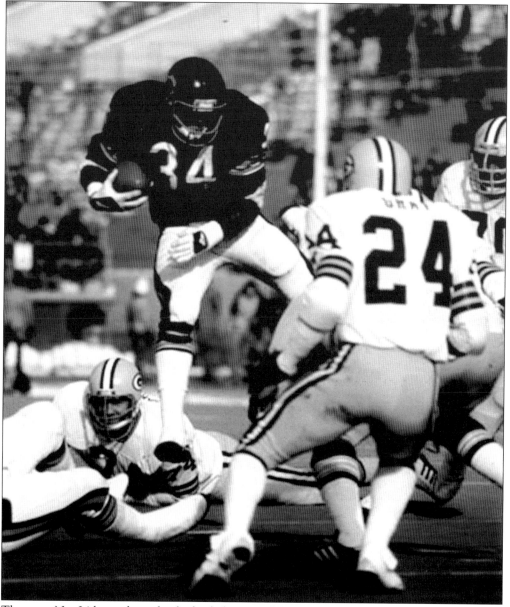

The great No. 34 leaps through a bedazzled group of Green Bay defenders and into the end zone. (Courtesy of Ron Nelson at Prairie Street Art.)

Here is a collage of ticket stubs from 1980s and 1990s, from Chicago's Soldier Field, where the Bear-Packer rivalry lives on. (From the collection of Bears fan Richard Carlson.)

1920s
*Record: Bears 6 Wins,*
*Packers 5 Wins, 4 Ties*

November 27, 1921
Bears (Staleys) 20,
Packers 20
Cubs Park (T)

October 14, 1923
Bears 3, Packers 0
Bellevue Park (W)

November 23, 1924
Bears 3, Packers 0
Cubs Park (W)

September 27, 1925
Bears 0, Packers 14
City Stadium (L)

November 22, 1925
Bears 21, Packers 0
Cubs Park (W)

September 26, 1926
Bears 6, Packers 6
City Stadium (T)

November 21, 1926
Bears 19, Packers 13
Cubs Park (W)

December 19, 1926
Bears 3, Packers 3
Soldier Field (T)

October 2, 1927
Bears 7, Packers 6
City Stadium (W)

November 20, 1927
Bears 14, Packers 6
Wrigley Field (W)

September 30, 1928
Bears 12, Packers 12
City Stadium (T)

October 21, 1928
Bears 6, Packers 16
Wrigley Field (L)

December 9, 1928
Bears 0, Packers 6
Wrigley Field (L)

September 29, 1929
Bears 0, Packers 23
City Stadium (L)

November 10, 1929
Bears 0, Packers 25
Wrigley Field (L)

1930s
*Record: Bears 12 Wins,*
*Packers 11 Wins, 1 Tie*

September 28, 1930
Bears 0, Packers 7
City Stadium (L)

November 9, 1930
Bears 12, Packers 13
Wrigley Field (L)

December 7, 1930
Bears 21, Packers 0
Wrigley Field (W)

September 27, 1931
Bears 0, Packers 7
City Stadium (L)

November 1, 1931
Bears 2, Packers 7
Wrigley Field (L)

December 6, 1931
Bears 7, Packers 6
Wrigley Field (W)

September 25, 1932
Bears 0, Packers 0
City Stadium (T)

October 16, 1932
Bears 0, Packers 2
Wrigley Field (L)

December 11, 1932
Bears 9, Packers 0
Wrigley Field (W)

September 24, 1933
Bears 14, Packers 7
City Stadium (W)

October 22, 1933
Bears 10, Packers 7
Wrigley Field (W)

December 10, 1933
Bears 7, Packers 6
Wrigley Field (W)

September 23, 1934
Bears 24, Packers 10
City Stadium (W)

October 28, 1934
Bears 27, Packers 14
Wrigley Field (W)

September 22, 1935
Bears 0, Packers 7
City Stadium (L)

October 27, 1935
Bears 14, Packers 17
Wrigley Field (L)

September 30, 1936
Bears 30, Packers 3
City Stadium (W)

November 1, 1936
Bears 10, Packers 21
Wrigley Field (L)

September 19, 1937
Bears 14, Packers 2
City Stadium (W)

November 7, 1937
Bears 14, Packers 24
Wrigley Field (L)

September 18, 1938
Bears 2, Packers 0
City Stadium (W)

November 6, 1938
Bears 17, Packers 24
Wrigley Field (L)

124

September 24, 1939
Bears 16, Packers 21
City Stadium (L)

November 5, 1939
Bears 30, Packers 27
Wrigley Field (W)

1940s
*Record: Bears 14 Wins,*
*Packers 3 Wins, 2 Ties*

September 22, 1940
Bears 41, Packers 10
City Stadium (W)

November 3, 1940
Bears 14, Packers 7
Wrigley Field (W)

September 28, 1941
Bears 25, Packers 17
City Stadium (W)

November 2, 1941
Bears 14, Packers 16
Wrigley Field (L)

September 27, 1942
Bears 44, Packers 28
City Stadium (W)

November 15, 1942
Bears 38, Packers 7
Wrigley Field (W)

September 26, 1943
Bears 21, Packers 21
City Stadium (T)

November 7, 1943
Bears 21, Packers 3
Wrigley Field (W)

September 24, 1944
Bears 28, Packers 42
City Stadium (L)

November 5, 1944
Bears 21, Packers 0
Wrigley Field (W)

September 30, 1945
Bears 21, Packers 21
City Stadium (T)

November 4, 1945
Bears 28, Packers 24
Wrigley Field (W)

September 29, 1946
Bears 30, Packers 7
City Stadium (W)

November 3, 1946
Bears 10, Packers 7
Wrigley Field (W)

September 28, 1947
Bears 20, Packers 29
City Stadium (L)

September 26, 1948
Bears 45, Packers 7
City Stadium (W)

November 14, 1948
Bears 7, Packers 6
Wrigley Field (W)

September 25, 1949
Bears 17, Packers 0
City Stadium (W)

November 6, 1949
Bears 24, Packers 3
Wrigley Field (W)

1950s
*Record: Bears 14 Wins,*
*Packers 5 Wins, 1 Tie*

October 1, 1950
Bears 21, Packers 31
City Stadium (L)

October 15, 1950
Bears 28, Packers 14
City Stadium (W)

September 30, 1951
Bears 31, Packers 20
City Stadium (W)

November 18, 1951
Bears 24, Packers 15
Wrigley Field (W)

September 28, 1952
Bears 24, Packers 14
City Stadium (W)

November 9, 1952
Bears 28, Packers 41
Wrigley Field (L)

October 4, 1953
Bears 17, Packers 13
City Stadium (W)

November 8, 1953
Bears 21, Packers 21
Wrigley Field (T)

October 3, 1954
Bears 10, Packers 3
City Stadium (W)

November 7, 1954
Bears 28, Packers 23
Wrigley Field (W)

October 2, 1955
Bears 3, Packers 24
City Stadium (L)

November 6, 1955
Bears 52, Packers 31
Wrigley Field (W)

October 7, 1956
Bears 37, Packers 21
City Stadium (W)

November 11, 1956
Bears 38, Packers 14
Wrigley Field (W)

September 29, 1957
Bears 17, Packers 21
*First game in new City*
*Stadium* (L)

November 10, 1957
Bears 21, Packers 14
Wrigley Field (W)

September 28, 1958
Bears 34, Packers 20
City Stadium (W)

November 9, 1958
Bears 24, Packers 10
Wrigley Field (W)

September 27, 1959
Bears 6, Packers 9
City Stadium (L)

November 8, 1959
Bears 28, Packers 17
Wrigley Field (W)

1960s
*Record: Bears 5 Wins,
Packers 15 Wins*

September 25, 1960
Bears 17, Packers 14
City Stadium (W)

December 4, 1960
Bears 13, Packers 41
Wrigley Field (L)

October 1, 1961
Bears 0, Packers 24
City Stadium (L)

November 12, 1961
Bears 28, Packers 31
Wrigley Field (L)

September 30, 1962
Bears 0, Packers 49
City Stadium (L)

November 4, 1962
Bears 7, Packers 38
Wrigley Field (L)

September 15, 1963
Bears 10, Packers 3
City Stadium (W)

November 17, 1963
Bears 26, Packers 7
Wrigley Field (W)

September 13, 1964
Bears 12, Packers 23
City Stadium (L)

December 5, 1964
Bears 3, Packers 17
Wrigley Field (L)

October 3, 1965
Bears 14, Packers 23
Lambeau Field (L)

October 31, 1965
Bears 31, Packers 10
Wrigley Field (W)

October 16, 1966
Bears 0, Packers 17
Wrigley Field (L)

November 20, 1966
Bears 6, Packers 13
Lambeau Field (L)

September 24, 1967
Bears 10, Packers 13
Lambeau Field (L)

November 26, 1967
Bears 13, Packers 17
Wrigley Field (L)

November 3, 1968
Bears 13, Packers 10
Lambeau Field (W)

December 15, 1968
Bears 27, Packers 28
Wrigley Field (L)

September 21, 1969
Bears 0, Packers 17
Lambeau Field (L)

December 14, 1969
Bears 3, Packers 21
Wrigley Field (L)

1970s
*Record: Bears 11 Wins,
Packers 9 Wins*

November 15, 1970
Bears 19, Packers 20
Lambeau Field (L)

December 13, 1970
Bears 35, Packers 17
Wrigley Field (W)

November 7, 1971
Bears 14, Packers 17
Soldier Field (L)

December 12, 1971
Bears 10, Packers 31
Lambeau Field (L)

October 8, 1972
Bears 17, Packers 20
Lambeau Field (L)

November 12, 1972
Bears 17, Packers 23
Soldier Field (L)

November 4, 1973
Bears 31, Packers 16
Lambeau Field (W)

December 16, 1973
Bears 0, Packers 21
Soldier Field (L)

October 21, 1974
Bears 10, Packers 9
Soldier Field (W)

November 10, 1974
Bears 3, Packers 20
Milwaukee County
Stadium (L)

November 9, 1975
Bears 27, Packers 14
Soldier Field (W)

November 30, 1975
Bears 7, Packers 28
Lambeau Field (L)

November 14, 1976
Bears 24, Packers 13
Soldier Field (W)

November 28, 1976
Bears 16, Packers 10
Lambeau Field (W)

October 30, 1977
Bears 26, Packers 0
Lambeau Field (W)

December 11, 1977
Bears 21, Packers 10
Soldier Field (W)

October 8, 1978
Bears 14, Packers 24
Lambeau Field (L)

December 10, 1978
Bears 14, Packers 10
Soldier Field (W)

September 2, 1979
Bears 6, Packers 3
Soldier Field (W)

December 9, 1979
Bears 15, Packers 14
Lambeau Field (W)

1980s
*Record: Bears 13 Wins,*
*Packer 7 Wins*

September 7, 1980
Bears 6, Packers 12
Lambeau Field (L)

December 7, 1980
Bears 61, Packers 7
Soldier Field (W)

September 6, 1981
Bears 9, Packers 16
Soldier Field (L)

November 15, 1981
Bears 17, Packers 21
Lambeau Field (L)

December 4, 1983
Bears 28, Packers 31
Lambeau Field (L)

December 18, 1983
Bears 23, Packers 21
Soldier Field (W)

September 16, 1984
Bears 9, Packers 7
Lambeau Field (W)

December 9, 1984
Bears 14, Packers 20
Soldier Field (L)

October 21, 1985
Bears 23, Packers 7
Soldier Field (W)

November 3, 1985
Bears 16, Packers 10
Lambeau Field (W)

September 22, 1986
Bears 25, Packers 12
Lambeau Field (W)

November 23, 1986
Bears 12, Packers 10
Lambeau Field (W)

November 8, 1987
Bears 26, Packers 24
Lambeau Field (W)

November 29, 1987
Bears 23, Packers 10
Soldier Field (W)

September 5, 1988
Bears 24, Packers 10
Lambeau Field (W)

November 27, 1988
Bears 16, Packers 0
Soldier Field (W)

November 5, 1989
Bears 13, Packers 14
Lambeau Field (L)

December 17, 1989
Bears 28, Packers 40
Soldier Field (L)

1990s
*Record: Bears 7 Wins,*
*Packer 13 Wins*

September 16, 1990
Bears 31, Packers 13
Lambeau Field (W)

October 7, 1990
Bears 27, Packers 13
Soldier Field (W)

October 17, 1991
Bears 10, Packers 0
Lambeau Field (W)

December 8, 1991
Bears 27, Packers 13
Soldier Field (W)

October 25, 1992
Bears 30, Packers 10
Lambeau Field (W)

November 22, 1992
Bears 3, Packers 17
Soldier Field (L)

October 31, 1993
Bears 3, Packers 17
Lambeau Field (L)

December 5, 1993
Bears 30, Packers 17
Soldier Field (W)

October 31, 1994
Bears 6, Packers 33
Soldier Field (L)

December 11, 1994
Bears 3, Packers 40
Lambeau Field (L)

September 11, 1995
Bears 24, Packers 27
Soldier Field (L)

November 12, 1995
Bears 28, Packers 35
Lambeau Field (L)

October 6, 1996
Bears 6, Packers 37
Soldier Field (L)

December 1, 1996
Bears 17, Packers 28
Lambeau Field (L)

September 1, 1997
Bears 24, Packers 38
Lambeau Field (L)

October 12, 1997
Bears 23, Packers 24
Soldier Field (L)

December 13, 1998
Bears 20, Packers 26
Lambeau Field (L)

December 27, 1998
Bears 13, Packers 16
Soldier Field (L)

November 7, 1999
Bears 14, Packers 13
Lambeau Field (W)

December 5, 1999
Bears 19, Packers 35
Soldier Field (L)

2000s
*Record: Bears 2 Wins,*
*Packers 8 Wins . . .*

October 1, 2000
Bears 27, Packers 24
Lambeau Field (W)

December 3, 2000
Bears 6, Packers 28
Soldier Field (L)

November 11, 2001
Bears 12, Packers 20
Soldier Field (L)

December 9, 2001
Bears 7, Packers 17
Lambeau Field (L)

October 7, 2002
Bears 21, Packers 34
Soldier Field (L)

December 1, 2002
Bears 20, Packers 30
Lambeau Field (L)

September 29, 2003
Bears 23, Packers 38
*First Game at new*
*Soldier Field* (L)

December 7, 2003
Bears 21, Packers 34
Lambeau Field (L)

September 19, 2004
Bears 21, Packers 10
Lambeau Field (W)

January 2, 2005
Bears 14, Packers 31
Soldier Field (L)